Solder TECHNIQUE Studio

SOLDERING IRON FUNDAMENTALS FOR THE MIXED MEDIA ARTIST

GIUSEPPINA "Josie" CIRINCIONE

NORTH
LIGHT
BOOKS

CREATEMIXEDMEDIA.COM
CINCINNATI, OHIO

DEDICATION

To my parents, my brother Joe (a.k.a. Pino) and Beth Lipham for being the sister I never had. To everyone who makes stuff just for the sake of making things, to all the shop owners for their support and to everyone who buys handmade. And lastly, to Baby Gorilla and TaTa Toothy for all the laughs.

A FIRST EDITION

BY S.K.W.

RAINING
(CONT.)

IGN OF DANGER
CRAWL INTO
AR AND SOUND
IN THIS CASE
WIGGLE) THE ALARM!

A BELL ON HIS COLLAR
WOULD BE OF VALUE.

NOW THAT WE HAVE
COVERED

Contents

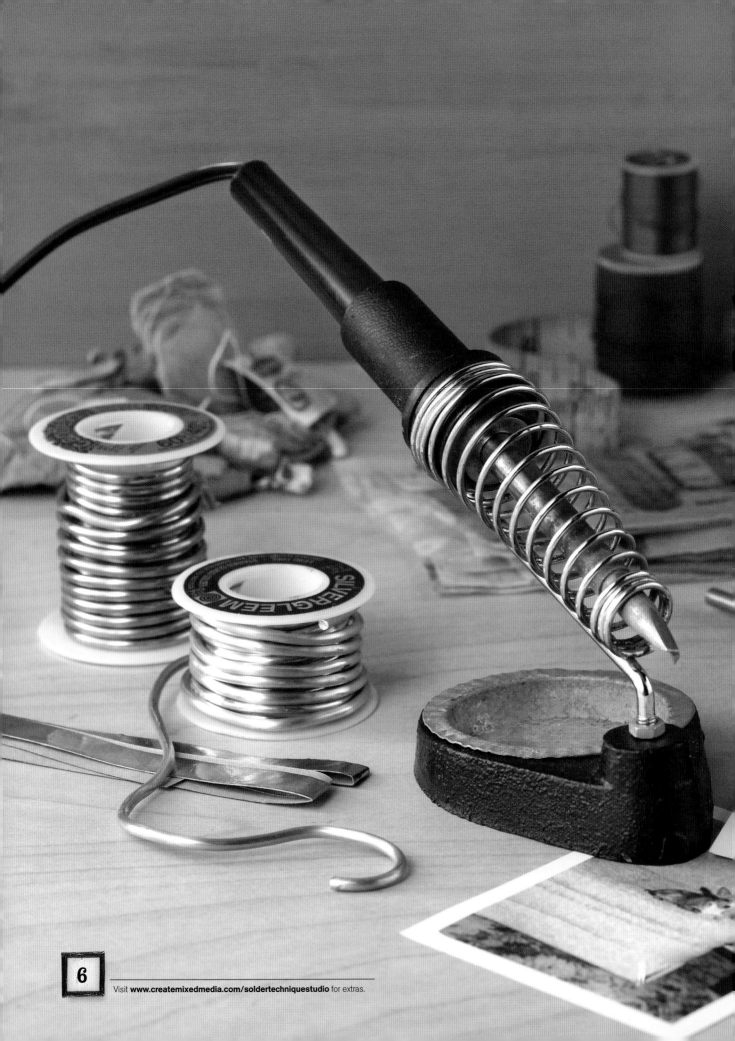

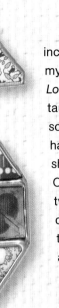

ince the release of my first book, *Collage Lost and Found*, I have taught numerous soldering classes and have learned much to share along the way. On average, I teach two to three soldering classes per month in the greater Phoenix area; there is still a high demand and growing interest in soldering. In fact, soldering is still the most popular technique I teach.

For most people, using a glass cutter and a soldering iron is still a mystery. The one question that still pops up is, "What else can I make besides microscope slide jewelry?" This book details a wide range of projects that encompass jewelry, collage and assemblage. All the projects shown push the crafter to another level, featuring items that people can use daily and that are a great alternative to traditional display settings.

Keep in mind that this is not a stained glass book. Although the same principles, tools and techniques often apply, there is a difference. Still, what you will learn in this book can be used to explore stained glass and vice versa. People trained in stained glass will find this book helpful for thinking outside the box beyond using one piece of glass as a sole medium.

When first learning how to solder you have to be patient. It takes time and lots of practice. I was so mad with myself the first time I tried that I didn't try it again for months. That's ridiculous. We all have to start somewhere. There's always going to be a learning curve if you are trying something new, but you can only get better from there. You have to stick with it. It's like anything you do for the first time; think how boring life would be if we gave up on everything we failed on the first try. If you are a perfectionist, you have to let that go. It's never going to be perfect. *It's handmade.* That's what gives it character.

One of the things I love most about teaching workshops is meeting all sorts of people. During one of my workshops, I talked to a grade school art teacher about that time in our lives when we lose the carefree attitude of not caring what people think. I don't have kids of my own, but based on my own experience as a child and what I have heard from others, awareness of how people judge us starts around the sixth grade. She said something else that has stayed with me. "Perfectionism stifles creativity."

We need to get back to that place where we are unfettered and not bothered by the opinions of others. Make stuff just for the sake of making it because it makes you happy. It's really that simple. Not everything is going to be a masterpiece. If you ever had the opportunity to visit an artist's studio, more often than not they had a pile of duds taking refuge in a corner. But the duds are what led them to their masterpiece. Let go and don't overthink the process.

Sign up for the free newsletter at **www.createmixedmedia.com**.

7

Soldering iron
temperature control

Safety glasses

Soldering iron

Safety gloves

Sal ammoniac block

Soldering iron
sponge

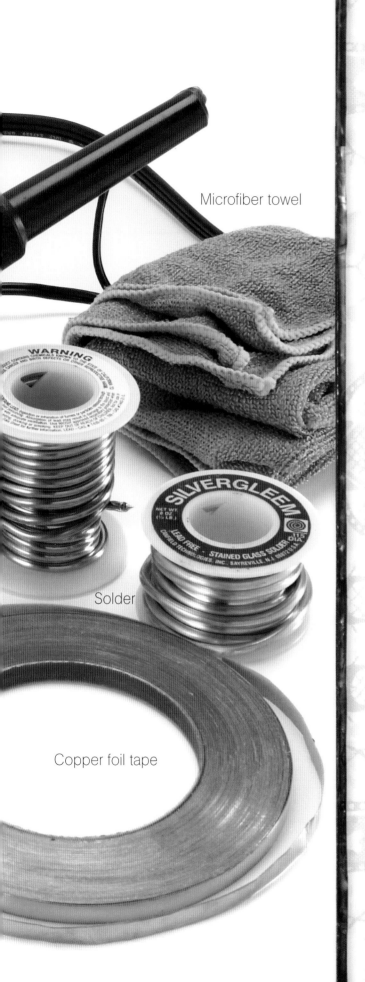

Microfiber towel

Solder

Copper foil tape

Don't let this section overwhelm you. Put on your big girl or boy pants and jump in headfirst.

You'll need to make a one-time investment in some basic tools for soldering. Having the right tools is so important that I recommend you buy the best equipment you can afford at the outset. High-quality instruments make soldering a much more pleasant experience. It took me a few years before I purchased my Weller soldering iron and Glastar temperature control, and it was the best investment I ever made. Now I can't imagine soldering without them. Make a commitment from the beginning to take good care of your tools.

The following pages are a general overview of what you will need to get started.

9

Sign up for the free newsletter at **www.createmixedmedia.com**.

BASIC SOLDERING TOOL KIT

For the projects featured in the book you will use some or all of the supplies listed below.

- 100-watt soldering iron with interchangeable tips
- Soldering iron stand
- Temperature control
- Solder
- Gloves: utility or leather
- Burnishing tool: bone folder or lathekin
- Flux: Lenox Sterling Paste, gel or liquid
- Flux brush or cotton swab
- Cross-locking, self-clamping tweezers
- Fine-grit manicure sanding sponge
- Clamps, a few different sizes
- Wet sponge for cleaning iron tip

- Sal ammoniac block for tinning
- Glass cleaner or rubbing alcohol
- Lint-free cloth or paper towels
- 200-grit diamond sanding sponge
- Running pliers
- Grozing pliers
- Copper foil tape, variety of sizes and color backings
- Toyo pencil-grip glass cutter and cutting oil
- Small handheld brush or architectural brush
- Cutting surface (For the projects in this book a piece of foam core or a cutting grid works great.)

- Metal ruler with foam or cork backing
- Craft knife with sharp blade
- Small detail scissors
- Self-healing cutting mat
- Safety glasses
- Polishing compound
- Patinas: Novacan Black and Jax Pewter Black
- Soldering surface
- Utility or Tonic shears
- Fine-tip and round-tip Sharpies
- Polishing cloth or old soft cotton tee shirt

NOTE

Keep your soldering tools together in a dedicated storage unit. For portability, my tool kit is a tool caddy with a built-in handle and organizer compartments. You can find these at most craft stores.

Visit **www.createmixedmedia.com/soldertechniquestudio** for extras.

BASIC SOLDERING TIPS

For easy reference I wanted to include some basic safety information and soldering tips that will come in handy. You will also see them repeated throughout. Think of them as your soldering mantras.

- When soldering and cutting glass, always put safety first.
- Always place your iron in a stand. Never set it down. Keep in mind that the stand gets hot, so always handle it by the base.
- Only hold the iron by the handle; never grab it by the heating element.
- Make sure your work table is well organized. Keep your table free of excess materials that you are not using.
- OCD is your friend. Never leave a hot iron unattended.
- Don't solder under a ceiling fan or air vent. Use a floor fan or open a window for ventilation.
- Make sure your legs are under the table when soldering. Trust me—hot molten solder and skin don't mix.
- Wear gloves and safety glasses when cutting glass.
- Wear safety glasses and a mask when grinding glass.
- When cutting glass keep your cutting surface and floor free of glass shards, splinters or chips.
- Wear rubber gloves when applying patina.
- Don't eat while soldering.
- No open drink containers.
- Always wash your hands after soldering.

- If you are pregnant, don't solder. You've waited this long, you can wait another nine months. Just look at the pretty pictures and dream.
- Your piece gets hot. Wear gloves or use self-clamping tweezers to move or hold your piece in place.
- You can't solder without flux. If your soldering isn't melting together or moving, apply flux or check your temperature control.
- Do not drag your soldering iron when building a bead. A bead is a little BB-size blob of hot molten solder that looks like mercury from an old school thermometer. Heat the solder all the way through using a tapping motion.
- Don't use your iron like a paintbrush. The only thing this accomplishes is hair pulling and uneven bumpy solder with sharp points and dimples.
- You have to melt your solder all the way through.
- If the solder runs off your tip, then your tip needs to be tinned or your temperature control is set too high.
- If your solder sets with a dull rough finish or will not flow, turn your iron up.
- Clean your tip throughout. A shiny tip is a happy tip.

- If you can't pick up a bead of solder, tin your tip.
- You are not frosting cupcakes. Use flux sparingly.
- Never spray glass cleaner directly on your piece. Spray your towel.
- If your hands are shaky, add your jump rings another day. Go have a drink and put your feet up instead.
- If you don't have a nice rounded edge, flux and add more solder. Melt the solder all the way through.
- Don't overwork your solder or your piece. If your piece gets too hot, the glass can crack, the solder will have a rough burnt appearance, and copper tape adhesive may ooze out from under the copper tape.
- Make sure you apply your foil evenly and burnish well.
- PRACTICE, PRACTICE, PRACTICE your techniques for the sake of practicing.
- Leave perfectionism at the door. Fixing one area almost always messes up another area.
- If you want perfection, buy machine-made.

SOLDERING IRON & TEMPERATURE CONTROL

Once I was sold on soldering as a medium of choice, I had to upgrade my tools. I learned the expensive way; buy quality tools at the outset or you will find yourself with two sets of soldering tools. My local stained glass store was extremely helpful in recommending the best equipment and supplies.

There are a few things to consider when choosing an iron. Here are my criteria:

- Interchangeable iron tips (³⁄₁₆" [5mm], ¼" [6mm] and ³⁄₈" [10mm] chisel tips)
- Minimum 100 watts
- Comfortable heat-resistant handle
- Feels lightweight and balanced

You will also need a temperature control or a rheostat. A temperature control is a separate unit with a receptacle for your iron. It does exactly what it's called—controls the temperature of your iron using an adjustable dial. Different solders melt at different temperatures; for example, lead-free solders burn at a higher temperature. Practice soldering at different temperatures to get a sense of how the materials react to heat settings. If your bead of solder runs off of your iron and puddles, your iron is too hot. If you can't melt your solder together or it dries cloudy and rough, your iron is too cool. You may have to try this a few times before you find a sweet spot. I use a fine-tip Sharpie to mark the sweet spot on my adjustable dial, and also write the type of solder directly on the controller at that dial position.

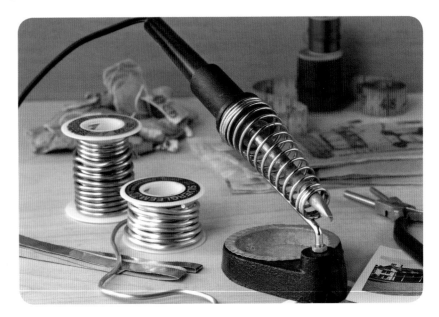

If your iron has interchangeable tips, apply an anti-seize cream to the threaded end of the tip, or the screw that holds the tip before you use your iron. Failure to do so can cause problems down the line. Metal expands and contracts when it goes from extremely hot to cold. If that happens over a long period of time, you will not be able to remove the tip. That means one of two things: either you need to buy a new iron, or you can contact the manufacturer and see if they can repair the iron.

Do not try to force the tip loose. Trust me—you will end up damaging your iron, making it unsafe.

Always place your iron in a stand. Never set it down. Keep in mind that the stand gets hot, so always handle it by the base. Only hold the iron by its handle; never grab it by the heating element. If your iron falls, fight your natural instinct to catch it. Get yourself out of the way and let if fall where it may.

Work in an organized manner. Make sure electrical cords are in no danger of getting burned. Always have your stand next to your iron. Keep things close so you are not reaching over or around your iron.

Don't turn your iron on until you are ready to use it. When I am ready to foil the last piece, that is when I turn on my iron. It heats up quickly. Leaving the iron on a high setting for long periods of time will shorten the life of your iron. If you are going to step away, turn it off. If you are still working and need to prepare something, turn your iron down to the lowest setting. Never walk away from your workspace with your iron on. When I finish I always turn it off or, just to be on the safe side, unplug the iron.

Visit **www.createmixedmedia.com/soldertechniquestudio** for extras.

TINNING YOUR IRON

You will want to tin for two reasons:

1. Your tip won't stay shiny.

2. You can't hold onto a bead of solder.

As you work, get in the habit of cleaning your tip. Before you turn your iron off, be sure to clean the tip and flood it with solder. This will extend the life of your tip and re-tin the tip for next time.

Before you turn to a sal ammoniac block, try tinning your tip on a wet sponge using solder (see steps 1–3). If that doesn't work, use a sal ammoniac block (see steps 4–5). The method is the same. Put some flux and solder on the block, and rub the tip on the block. You want to make sure you do this outside and don't breathe in the fumes.

If neither method keeps the tip tinned, you may need a new tip.

From time to time, take the tip off to clean out the barrel of any debris and add a bit more anti-seize cream. If you take care of your tools, they will last you a lifetime.

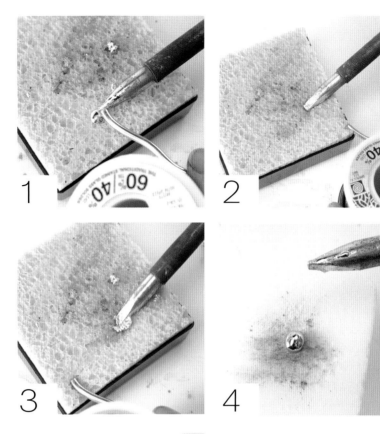

1

2

3

4

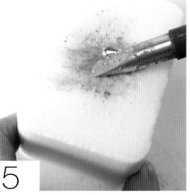

5

"A SHINY TIP IS A HAPPY TIP."

Sign up for the free newsletter at **www.createmixedmedia.com**.

SOLDER

What is a bead of solder? To create a bead of solder, start by unrolling a length of material from your coil. Swipe your hot iron against the length of solder; this will deposit a rounded molten ball of melted solder onto your iron. You have now created a bead that you will place on the copper foil tape applied with flux.

The main purpose of solder is to build a bezel around your glass. A beaded edge is when you layer beads of solder on top of each other to create a nice rounded bezel. When it cools, it creates a hard rounded edge that houses your glass and whatever goodie you choose to encase. Solder will not stick to glass, so you need to first wrap the glass with copper foil tape before soldering.

Solder is made up of a combination of tin and lead. The numbers designate the tin-to-lead ratio (e.g., 60/40). Most solders contain lead and are less expensive than their lead-free

counterparts. If you practice basic safety rules, you will not have any problems with lead contamination.

When choosing solder, think of the application. If it's something that is going to be handled or come in contact with food, use lead-free solder; for jewelry use Silvergleem. For all other purposes I use 60/40 solder. It's easy to work with, works great with copper foil and sets up nicely to build a rounded beaded edge.

For all you beginners out there, it's harder to work with lead-free solder. I find that lead-free doesn't melt as nicely as leaded solder and sets up with a dull and cloudy finish. Silvergleem, which is lead-free and contains silver, is cost prohibitive when it comes to learning a new technique. I recommend starting with 60/40 and working your way up to the lead-free solders.

If you plan to sell your pieces and they are decorative, be sure

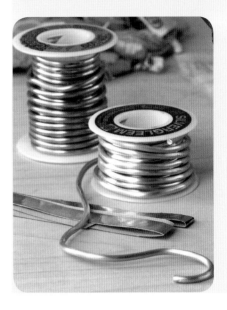

that the tag says, "Not for food—only for decorative purposes." If you are selling jewelry, use only lead-free or Silvergleem. If it's for yourself, use your own discretion.

Do not buy your solder at a hardware store. Most hardware store solders contain a rosin core (flux in the center) and burn dirty; this is plumbing solder. Whenever possible I prefer Canfield brand solder.

TIP

If you are worried about the lead content of your creation, apply a thin layer of clear nail polish over the solder for protection.

Visit **www.createmixedmedia.com/soldertechniquestudio** for extras.

My solders of choice

60/40 or 63/37

The main difference between these two solders is that 63/37, called "Thin Ultimate," is thinner in gauge. Both solders set up nicely, work great with copper tape, create a rounded beaded edge and can be polished to a high shine or are easily patinaed for an antique finish.

Lead-free

For some decorative pieces and anything that is going to be manhandled, choose lead-free. The frustration factor that goes along with using lead-free solder can be a turnoff to the whole process, so practice your skills before tackling a lead-free project. Once you get your technique down, go for it!

Silvergleem

Silvergleem is lead-free and contains a small percentage of silver. It polishes up beautifully and when buffed out has a mirror-like finish. This is the only solder I use when making jewelry. Remember: this is not for practicing. It burns at a higher temperature and may leave a small whitish spot when it hardens. It's the nature of the beast.

COPPER FOIL TAPE HIGHLIGHTS

You can't solder without copper foil tape. Here are some key points about this medium and its function.

- Copper foil tape comes in a variety of sizes and different colored adhesive backings.

- Don't work off the roll. Always cut your length after measuring the perimeter of your piece, and peel the backing away slowly as you work around the piece.

- Choose a tape size that will overlap the front and back of your piece by a couple millimeters.

- Your wrapping technique is critical; copper foil tape is the foundation of the structure of your piece.

- Copper foil tape is sold in a variety of sizes and formats; most common are rolls measuring ¼" (6mm), ⅜" (10mm) or ½" (12mm) in width. It is also available in a 12" × 12" (30 cm × 30 cm) sheet. Various applications of different types are featured throughout the book.

Solder + Copper Foil Tape

FLUX

In layman's terms, the process of soldering is joining two metals together. Flux aids in the bonding of the two metals and removes any oxidation that may occur when the copper foil tape is exposed to air. You can't solder without flux. If your solder doesn't want to flow, add flux; it's that simple. When building a bead or applying solder on top of solder, apply a thin layer of flux first. You don't need much—remember, you are not frosting cupcakes. When working with two pieces of glass with something encased in the middle, you have to be careful not to apply too much flux because it can seep under the copper foil tape and damage your images.

When applying liquid or gel flux, I use a cotton swab or a small detail brush. When using paste, I use a flux brush or, depending on the size of the piece, a small detail brush. Keep those brushes separate and use them only for flux. If flux gets on the glass, it can be cleaned up. When soldering found objects, be more careful. Try not to get flux on your object or paper backing. Flux may stain your piece.

These images illustrate the power of flux.

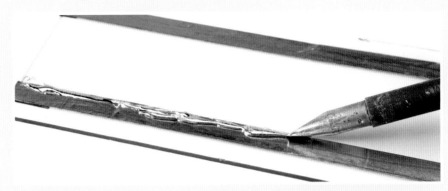

In the first image we apply the solder without flux. Notice that the solder is all clumped together and does not flow onto the surface of the copper tape. This is unworkable and impossible to manage; this is what happens when you don't use flux.

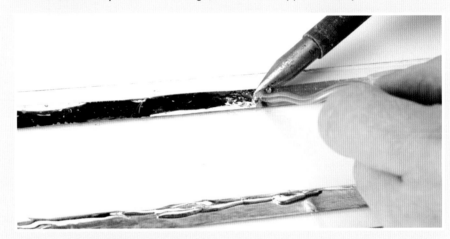

In the second example, you can see the dramatic smoothing of the solder after flux has been applied to the copper tape. The results are vastly improved, as the flux has provided a workable surface free of bumps and irregularities.

For the most part I use gel flux though others prefer liquid. If you have flux on hand, use what you have. If you find it's not to your liking, try a different type. No matter which you choose, do not overuse—that's your flux mantra.

Liquid flux

With the consistency of water, liquid flux tends to dry out quicker than gel or paste flux. Because of this, you tend to use more. Just because you can't see it doesn't mean it's not there. Liquid flux likes to spread.

Gel flux

The consistency of hair gel, this flux tends to stay where placed, but that doesn't mean you need to use more. A little gel flux goes a long way.

Paste flux

This flux is easy to work with and stays put where it is placed. Use sparingly. If I use paste flux, I prefer to use Lenox Sterling brand. It's water soluble and tends to clean up easier than other pastes.

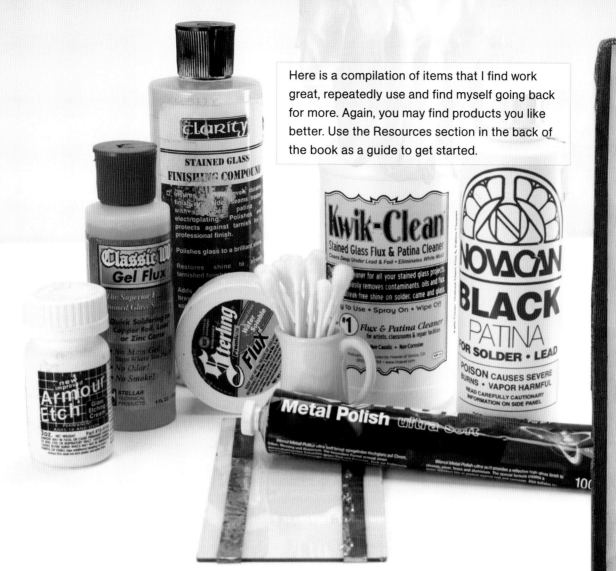

Here is a compilation of items that I find work great, repeatedly use and find myself going back for more. Again, you may find products you like better. Use the Resources section in the back of the book as a guide to get started.

Armour Etch: Use this chemical process to etch text or shapes onto glass. Use contact paper to make custom etching masks as shown in the *Boxed In* project.

Clarity Stained Glass Finishing Compound: This polishing agent leaves a bright clear shine on your solder. It's not as messy as metal polish and reminds me of car wax. When it sits for a long time, it tends to separate, so I add a few small pebbles to the bottle as they help shake things up. To polish, apply the finishing compound, or metal polish, to a rag and buff out until you reach your desired look.

Kwik-Clean: This liquid spray is great for removing excess flux and cleaning your final project. Do not spray directly on your piece; spray onto your towel instead. If you don't have Kwik-Clean, no worries, you can use rubbing alcohol.

Novacan Patina: This liquid gives a dark, rich finish when applied to leaded solder. If you want an antiqued look, make sure to patina before you apply wax or polishing compound to your piece. For lead-free solders, Jax Pewter Black Patina will give a gunmetal look.

When applying patina I like to use a cotton swab. Pour the patina into a separate container; small sauce containers work great. Don't overpour; you can always add more. Discard after use. You can apply wax or polish over your patina for added luster; keep in mind it will change the color and don't overbuff.

Metal polish: With the consistency of toothpaste, metal polish tends to be messy, but when buffed, gives solder a brilliant shine. Use sparingly; you can also use this over patina for a shinier finish.

17

Sign up for the free newsletter at **www.createmixedmedia.com**.

PLIERS & TWEEZERS

Every tool kit needs a variety of pliers and tweezers for soldering projects. The ones I use the most are running pliers, grozing pliers and self-clamping, cross-locking tweezers.

Running pliers

Running pliers have rubber tips. The bottom inside of the pliers has a bump, the top inside is flat, and the top outside has a mark that you line up with your score. When you apply light pressure, the bottom curve will push up into the score and the flat edge will push down. You will start to see the line run and the glass will split in half.

Cross-locking, self-clamping tweezers

These tweezers are your best friend. I use them throughout the whole soldering process. They are like a third hand; they help stabilize your piece and are perfect for setting jump rings.

Grozing pliers

Grozing pliers are used to pull glass apart after cutting, or to nibble away to shape your glass. If you are cutting straight lines, you will not have much use for them, but once you get into cutting shapes, they are a must-have. They are the perfect tool for pulling excess glass away from deep curves.

Double-barrel pliers

Double-barrel pliers are used to make jump rings in different diameters.

Needle-nose pliers

Needle-nose pliers are great for taking pieces apart. Be sure to wear gloves when pulling hardened pieces of solder off glass and be extremely careful. When pulled and picked apart, hardened solder is knife-edge sharp. I learned that the hard way.

Visit **www.createmixedmedia.com/soldertechniquestudio** for extras.

CLAMPS

Clamps come in a variety of sizes and have an infinite number of uses. I generally use the smallest clamps for jewelry when making charms and small toggle pieces. Clamps can also be used to stabilize your pieces when applying jump rings and as braces when soldering your piece. Their main purpose is to keep all your parts together when wrapping your piece with copper foil tape. Below is a variety of the different sizes and styles of clamps I keep next to my workstation.

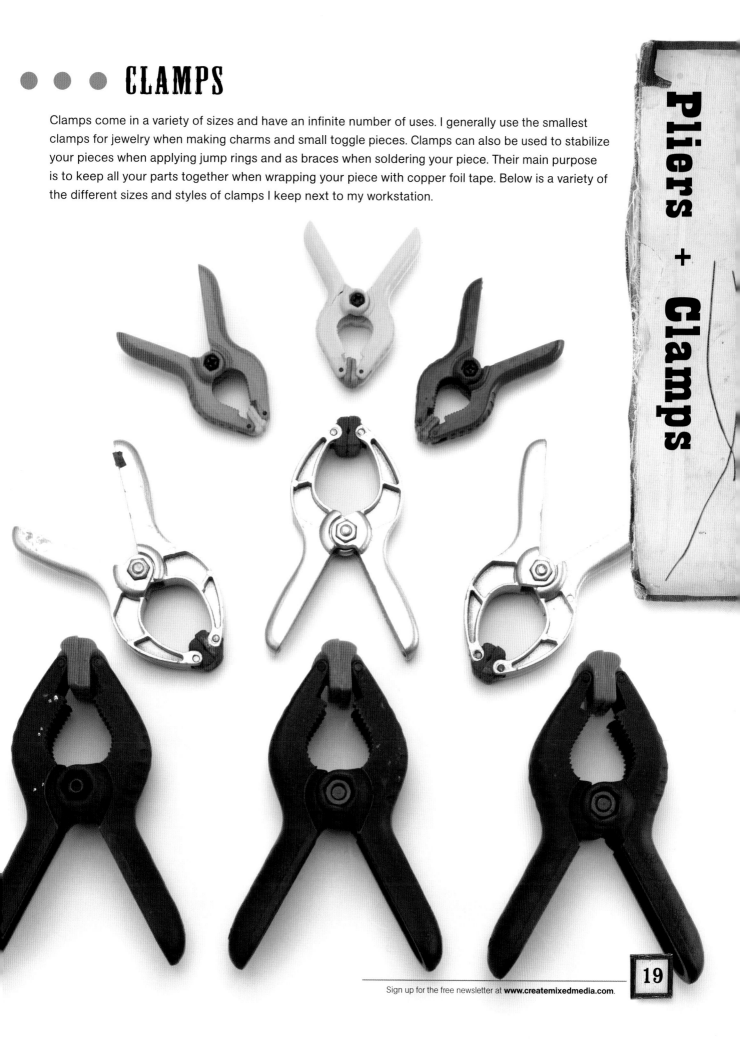

OTHER TOOLS

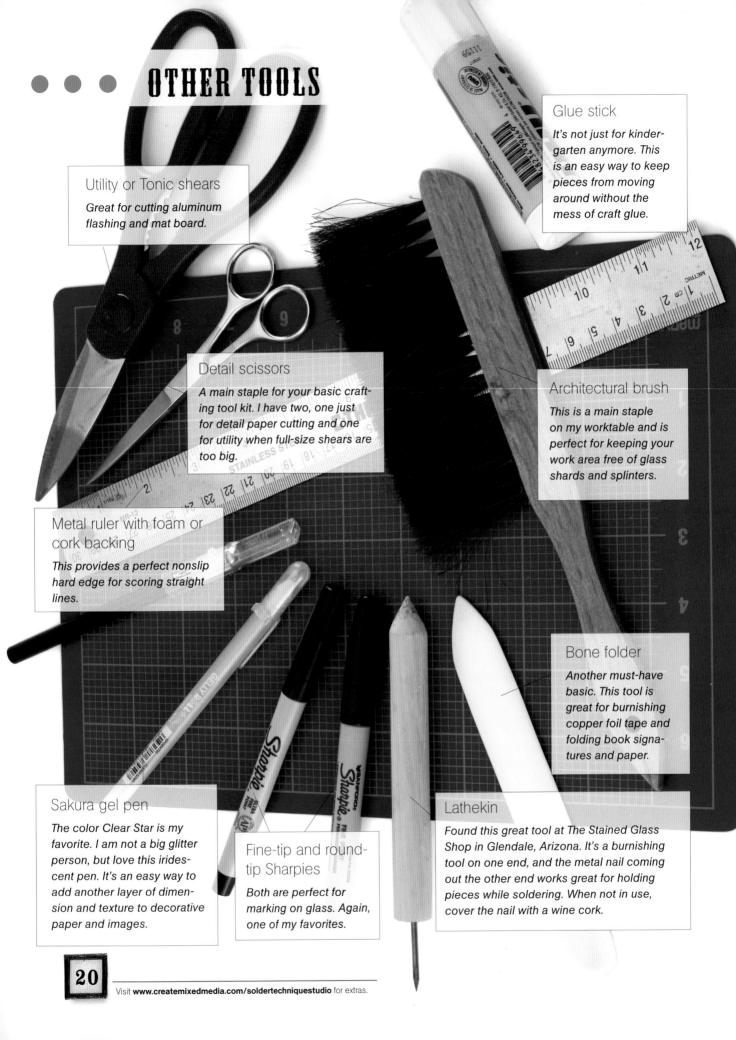

Utility or Tonic shears

Great for cutting aluminum flashing and mat board.

Glue stick

It's not just for kindergarten anymore. This is an easy way to keep pieces from moving around without the mess of craft glue.

Detail scissors

A main staple for your basic crafting tool kit. I have two, one just for detail paper cutting and one for utility when full-size shears are too big.

Architectural brush

This is a main staple on my worktable and is perfect for keeping your work area free of glass shards and splinters.

Metal ruler with foam or cork backing

This provides a perfect nonslip hard edge for scoring straight lines.

Bone folder

Another must-have basic. This tool is great for burnishing copper foil tape and folding book signatures and paper.

Sakura gel pen

The color Clear Star is my favorite. I am not a big glitter person, but love this iridescent pen. It's an easy way to add another layer of dimension and texture to decorative paper and images.

Fine-tip and round-tip Sharpies

Both are perfect for marking on glass. Again, one of my favorites.

Lathekin

Found this great tool at The Stained Glass Shop in Glendale, Arizona. It's a burnishing tool on one end, and the metal nail coming out the other end works great for holding pieces while soldering. When not in use, cover the nail with a wine cork.

Visit **www.createmixedmedia.com/soldertechniquestudio** for extras.

SOLDERING SURFACES

I am fortunate enough to have a dedicated workroom. Therefore my work table is just that, a surface that at the end of the day I don't care what it looks like (not to be confused with keeping it tidy). At home and in workshops, I solder on paper or foam core; I never solder directly on my work surface. It's a messy technique, and having a soldering surface makes for easy cleanup. If the only table in the house is your grandma's antique table, use common sense and place padding over your soldering surface.

If you don't have a dedicated work table, or the thought of soldering on a paper surface freaks you out, here are a few options:

- Fire board
- Soldering mat—stained glass store
- Ranger Non-Stick Craft Mat
- Soldering work board—stained glass store
- Aluminum cookie sheet
- Cement board (a.k.a. shower board)

➜ Dimensional pieces need to be propped and held in place before you begin soldering. I made my own weights. I filled an assortment of gift boxes with sand and covered them with tape. Be inventive; see what you have around the house that can double as a weight.

Throughout the book you will see me use the term *tack solder*. Essentially it's like adding a drop of glue onto two objects to hold them together. Tack soldering is used when you have more than one piece you need to hold together so you can move the pieces around while soldering and they will not come apart.

➜ The most important thing when cutting out images is that the paper does not extend beyond the perimeter of the glass. You can cut your image out one of two ways. Both are discussed in the *Toggle-Clasp Pendant* project. If you cut your image a bit too small, no worries. Remember, the copper foil tape overlaps the edges by a few millimeters. Because of the overlap make sure there is nothing on the outer edges of your image that is important. It will get covered. It's a great way of cutting people out of pictures. Just kidding.

Note: For most of the projects you will notice I have not called out glass size and copper foil tape width. I pinky swear I didn't do this on purpose; there is no way of my knowing the thickness of glass you are working with. Plus, I don't want you to think one size fits all. The beauty of learning how to cut glass is that it allows you to bust out of predetermined constraints.

All the projects in the book can be patinaed or polished—your choice.

Other Tools + Soldering Surfaces

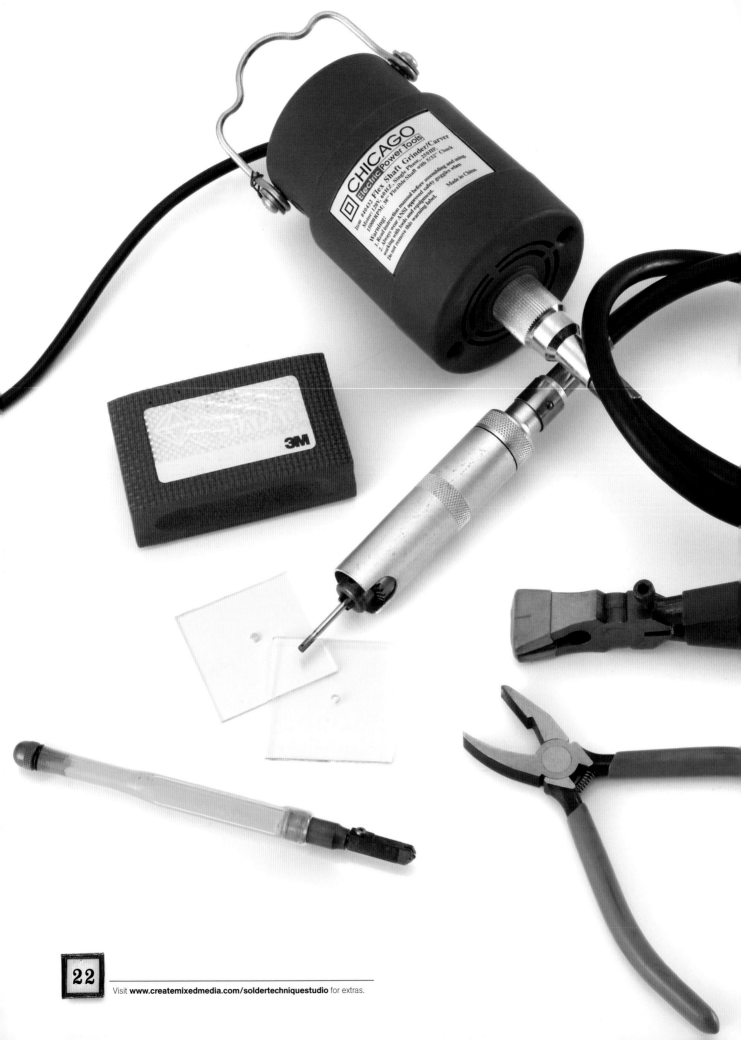

Visit **www.createmixedmedia.com/soldertechniquestudio** for extras.

There are plenty of precut glass and bevels out there that come ready to use, but if you learn how to cut your own glass, your creativity will not be stifled by predetermined size constraints. The following pages go into further detail, but here are a few basic tools you will need for glass cutting:

- Toyo pencil-grip glass cutter with cutting oil
- Grozing pliers
- Running pliers
- Flex shaft drill
- 200-grit diamond sanding sponge
- Glass grinder

Don't be afraid or timid in your efforts to cut glass. It will take you a few tries to get the feel for working with this medium. Try simple shapes like squares and rectangles, and work your way up to curved edges, like ellipses, hearts and circles.

I get most of my glass by reusing picture frame glass that I find while thrifting and garage sale hunting. This is a readily available and affordable material, plus it comes in a wide range of sizes. The thickness of the glass varies between frames, and that's why there is a variety of copper foil tape widths.

When cutting glass

think of it as scoring a piece of paper. Once you get a feel of how much pressure you need to apply, it's a fairly easy technique to master. If you plan on cutting multiple pieces of glass that need to be the same size, look into a Morton glass cutting system. It's essentially a jig for cutting glass. For more information and video tutorials, check out their site: mortonglass.com.

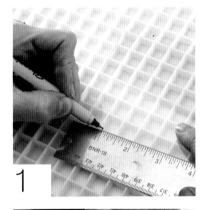

Materials

- Fine-tip Sharpie
- Metal ruler with corked back
- Glass
- Toyo pencil-grip glass cutter and cutting oil
- Safety glasses & gloves
- Cutting grid or piece of foam core larger than the glass
- Running pliers
- 200-grit diamond sanding sponge

SAFETY FIRST

- Make sure you wear safety glasses and gloves.

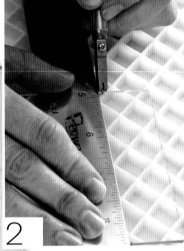

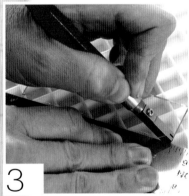

1 Using your ruler and fine-tip Sharpie, measure 1" (25mm) in from the outer edge of the glass. Mark it by making tick marks with the Sharpie. Repeat this measurement on the other edge of the glass. Loosen the top of the cutter to release the cutting oil. If you are getting too much oil, tighten it up a bit.

2 Notice that the cutting wheel is in the center of the cutting head. Place the ruler a couple millimeters away from the tick marks. Place the wheel on the mark and adjust the ruler so that the wheel sits right on the mark and the edge of the ruler is touching the outside edge of the cutting head. The ruler is only used as a straight hard edge that will guide the cutter.

3 Make the same adjustment at the top. Apply enough pressure on the ruler so it does not slide around on the glass. For good measure, place the wheel on the tick mark at the top and bottom just to make sure the ruler hasn't moved. Grasp the cutter with the screw facing up. Hold the cutter like a pencil and hold it perpendicular to the glass. You can cut away from you or towards you—whatever feels most natural. Set the wheel on the tick line and drag the cutter along the edge of the ruler until you get to the opposite edge. Try not to go over the edge. You want to hear a zipping sound as you are cutting. If you have big chips in your score, you are pushing too hard.

Visit **www.createmixedmedia.com/soldertechniquestudio** for extras.

4 Put on your gloves and safety glasses. Grasp the glass on either side of the cut as if you were trying to break something in half with your two hands. You want to break away from the cut.

5 Apply light pressure on each side of the cut. Keep your arms and elbows straight, then simply twist your wrists (your right wrist will turn clockwise and your left will turn counterclockwise), and snap.

6 If you cut larger pieces of glass or need to break shapes out of glass, use running pliers with an adjustment screw. Grasp the glass with the pliers and tighten the screw so the opening of the pliers is the same as the thickness of the glass. Remove the pliers from the glass. Loosen the screw a turn (to the left). Hold the running pliers with the line facing you and the bump on the bottom. 6a–Place the scored glass into the pliers (score facing you). Line up the score with the line mark on the top of the pliers and gently squeeze the pliers. The tightness of the screw should be relative to the thickness of the glass, so when you squeeze the pliers, the pressure forces the bump up under the score and snaps the glass.

7 Depending on your cut, there may be some flares and sharp edges. These can be extremely dangerous. If this happens, luckily it's an easy fix. If you see any flares, brush over the edges of your freshly cut glass over with a 200-grit diamond sanding sponge like you would use an emery board.

8 Even if you don't have any flares, you should still round off the corners. When filing, sand in the same direction—don't go back and forth. Sanding the corners is important not only for your safety, but also in later steps of the soldering process. When wrapping copper foil tape around the corners, there is less chance of puncturing the tape.

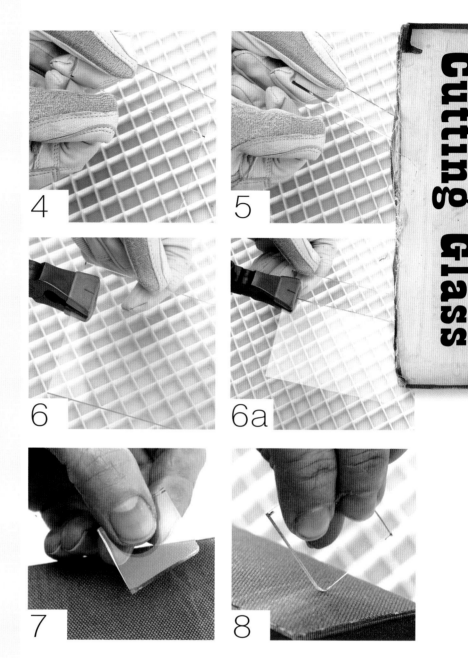

NOTE

When you are scoring the glass, you are essentially rearranging the glass's molecules so that when you tighten on the glass, the glass snaps.

25

Sign up for the free newsletter at **www.createmixedmedia.com**.

CUTTING SHAPES: BIRD

Once you have mastered straight lines, the next step in glass cutting is to work on curved edges. Put on your patience hat for this; remember this takes practice and you won't master it your first few cuts. For this you will need the items listed below.

1

Materials

- Shape template (back of the book)
- Round-tip Sharpie
- Glass
- Safety glasses & gloves
- Toyo pencil-grip glass cutter and cutting oil
- Cutting grid or piece of foam core larger than the glass
- Running pliers
- Grozing pliers
- 200-grit diamond sanding sponge

SAFETY FIRST

- Make sure you wear safety glasses and gloves.

2

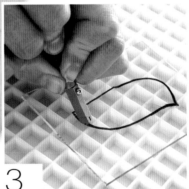
3

1 Trace the shape of the pattern on the glass using a round-tip Sharpie. Your glass should always be bigger than the shape. Here you will cut from the edge with the curve falling in the middle of the cut. (Because this is a free-standing dimensional piece that doesn't need to fit a predetermined size, I score along the outside of the marker line.)

2 When cutting out shapes you will need good control. Use both hands to guide the glass cutter. Place one hand toward the middle of the cutter and the other directly below that with your fingers gripping the area just above the cutting wheel. Your hands should be stacked.

3 Your hands should be stacked at this point. You will want to start by cutting the inner curves first and then any straight cuts. Be patient because it takes a series of cuts to release a shape from the center of a piece of glass. Think of it as breaking a shape out of something solid; like breaking out of prison, you have to take a series of steps in order to break free. (Just saying here—I've never actually been to prison….)

Visit **www.createmixedmedia.com/soldertechniquestudio** for extras.

4-5 Start with the deepest curve. Place the cutter on the edge of the glass and start cutting until you meet the line. Follow the curve until you feel you can't follow it anymore, then go off the edge of the glass.

6 Don't forget to put on your gloves and glasses. Use the running pliers and apply pressure on the line. Remove that piece of glass.

7 Place the cutter where you left off on the curve and follow that curve to the edge of the glass.

8 Holding the glass firmly in one hand, use the grozing pliers and pull the cut piece away from the shape. Notice the open curve of the pliers resembles a smile.

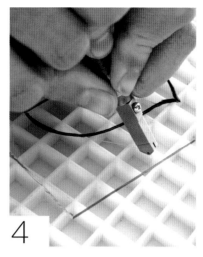

4

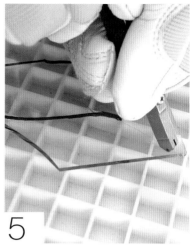

5

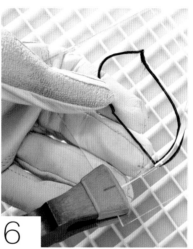

6

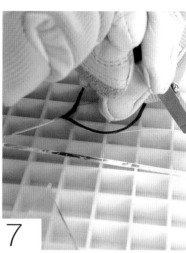

7

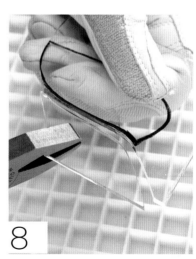

8

TIP

If the glass doesn't want to break or you don't get a clean break, it's important that you don't try to score over the same line. You will only damage your cutting wheel and there is a greater possibility of the glass splintering, thus making it easier to cut yourself. Measure again and break off the bad cut.

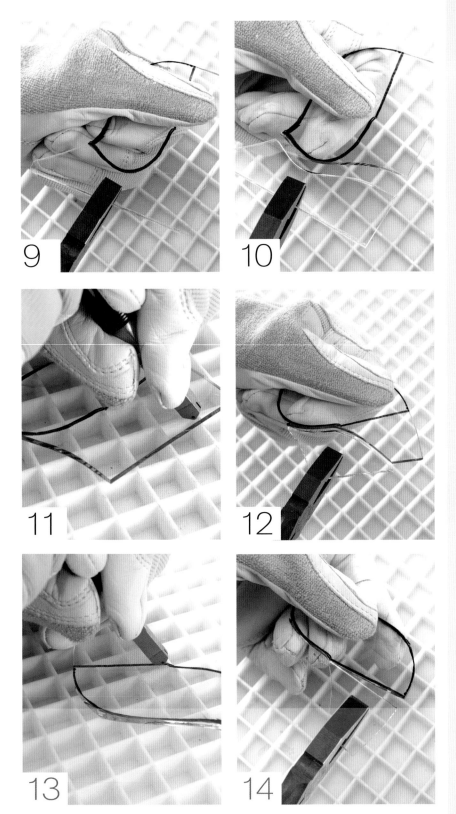

9–12 Repeat steps 6–8 until all the curves are cut.

13 Cut the straight line.

14 Use the grozing pliers and pull the cut piece away from the shape. File the edges and round off the pointed tips with a 200-grit diamond sanding sponge.

Once you've gotten the hang of cutting shapes, check out the *Tweet* project, which is based on the bird shape you've cut.

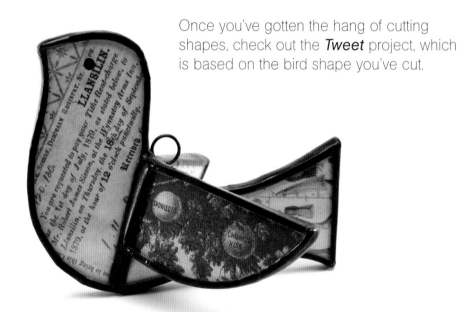

29

Sign up for the free newsletter at **www.createmixedmedia.com**.

When cutting shapes

always cut the deepest curve first. You will have to cut from an edge going into a curve and coming back out onto an edge. It's physically impossible to cut out a shape in one fell swoop. You are trying to release the shape from the larger piece.

Materials

- Shape template
- Round-tip Sharpie
- Glass
- Safety glasses & gloves
- Toyo pencil-grip glass cutter and cutting oil
- Cutting grid or piece of foam core larger than the glass
- Running pliers
- Grozing pliers
- 200-grit diamond sanding sponge
- Glass grinder, as needed

SAFETY FIRST

- Make sure you wear safety glasses and gloves.

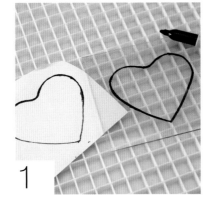

1

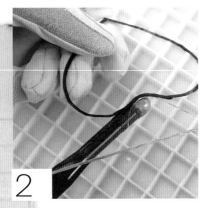

2

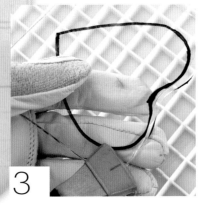

3

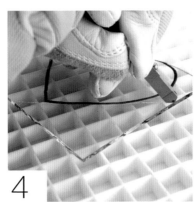

4

1 Trace the heart shape on the glass using a round-tip Sharpie. Remember your glass should be bigger than your shape.

2 Put on your gloves and glasses. Holding the glass cutter with both hands stacked on top of each other, cut the inside deepest cut first from the top of the heart. Notice how the cut looks like a U. Use the ball end of the cutter to help run the score line. Use grozing pliers and pull the cut piece out. In a circular fashion start releasing the shape out of the glass, cutting and pulling as you go.

3–13 Work your way around the heart, cutting and pulling until the shape is released from the center of the glass. Again, keep in mind you need to put your patience in the front of the line when cutting out shapes. File the edges with a 200-grit diamond sanding sponge.

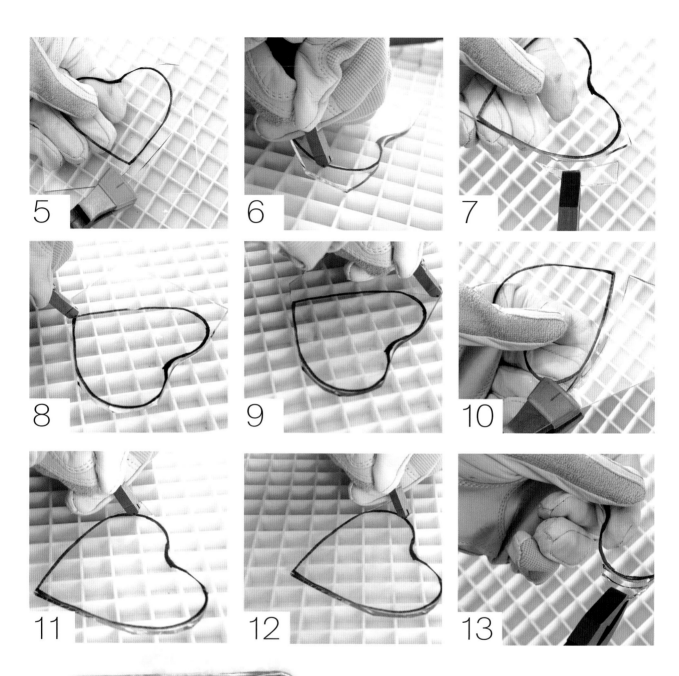

5 6 7

8 9 10

11 12 13

TIP

Use the ball end of the cutter to tap the underside of the score. This will help run the score line. Gentle tapping!

31

Sign up for the free newsletter at **www.createmixedmedia.com**.

● ● ● CUTTING CIRCLES

If you have a lens cutter, cutting circles is fairly easy. Most lens cutters have adjustable cutting arms that allow you to cut a variety of diameters. Again, this is something you will have to practice and is surprisingly easier than cutting shapes.

Materials

- Easy-Cut Lens Cutter, cuts ½" (12mm) to 5" (13cm) diameters
- Cutting grid or piece of foam core to work on
- Safety glasses & gloves
- Cotton swab
- Glass
- Toyo pencil-grip glass cutter and cutting oil
- Running pliers
- Grozing pliers
- 200-grit diamond sanding sponge
- Glass grinder, as needed

SAFETY FIRST

- Make sure you wear safety glasses and gloves.

1 A circle cutter has a crank and handle, and a bar at the bottom with the cutting wheel attached. Measurements are marked on the bar, so you can adjust for what size circle you want.

2 The circle cutter does not have cutting oil, so use a cotton swab to put a small quantity of oil on the tip of the cutting wheel.

Visit **www.createmixedmedia.com/soldertechniquestudio** for extras.

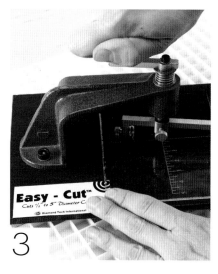

3

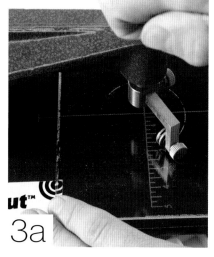

3a

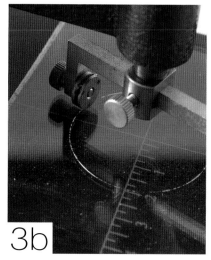

3b

4

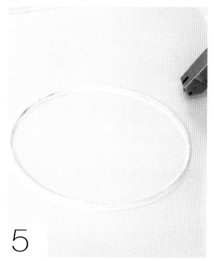

5

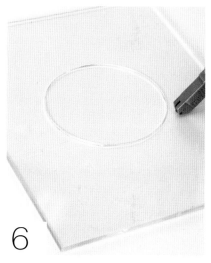

6

3 The glass size needs to be larger than the size of the circle you want to cut out. 3a—Place the glass on the lens cutter platform and then push the crank down and turn the crank. Keep even pressure when turning the crank. 3b—When you get to the starting point, overlap the cut approximately ¼" (6mm). Then stop turning the crank and release the pressure. DO NOT go over the score more than once.

4 Flip the piece of glass over onto a piece of foam core, score-side down. Using the ball on the end of the cutter, gently push along the score line to release the circle shape from the glass. As you do this you will see the score line run or begin pulling away from the glass. Once you have applied pressure around the score line, turn the glass over.

5 Starting at the outside edge of the glass, make a straight cut

towards the circle, stopping approximately ⅛" (3mm) from the score.

6 Repeat step 5. Do this a total of four times (two lines on the bottom, two lines on the top). It will resemble an H with a circle in the center. Remember, don't cut all the way to the score. Stop approximately ⅛" (3mm) away from the score for all four lines.

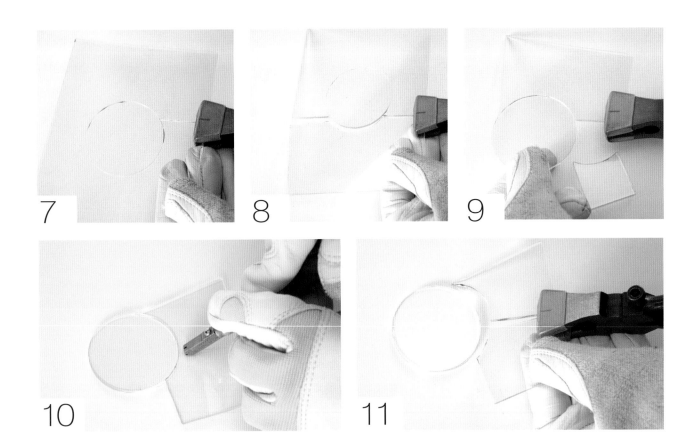

7–11 Put on your gloves and glasses. Using running pliers, place the line on the tool to the score line on one of the ends of the H cuts you just made and squeeze the tool. The circle should snap from its boundary. If necessary, repeat this for all H lines.

If the circle does not release, grasp the edge of the glass with the grozing pliers (with the smile curve facing up), and hold the opposite side and pull the glass away from the cut. If that doesn't work, cut a few more straight lines from the outer edge towards the circle and use the running pliers again. Repeat until the circle is released.

12 After smoothing all the flares, this circle is ready to go. Flares and jagged edges are extremely dangerous. This is the reason it's important to practice safety. They are as sharp as a surgical knife. If you have a lot of rough edges and flares, grind the edges of the circle.

13 If the glass doesn't have a lot of jagged edges, use a 200-grit diamond sanding sponge instead.

GLASS GRINDER

Materials

- Glass grinder
- Water
- Safety glasses
- Glass shape

If you plan on cutting shapes, invest in a glass grinder. They're typically under $100 and well worth the expense, as it is an easy tool to master. A few things to keep in mind when using a glass grinder are:

1. Always put water in the reservoir.
2. Wear safety glasses.
3. Start with the machine on, and hold on tight to your glass.

Unlike stained glass projects, which use one piece of glass for a section of a larger pattern, most of the projects in this book use two pieces of glass, and the shapes need to match.

A grinder allows you to shape glass to fit a pattern, fine-tune shapes, and remove any flares or rough, jagged edges left from cutting the shapes out of glass.

Make sure the grinder reservoir is full of water and that the sponge is pushed down into the reservoir with the top portion touching the grinding wheel. This is extremely important. The wet sponge collects ground-down glass powder and shards. You definitely don't want to breathe in glass dust. The water also acts as a lubricant and keeps the grinding wheel and glass cool. The wetness minimizes the pieces that could fly off, but there will still be some spatter. Safety first. Be sure you wear your safety glasses and mask and work in a clean area.

Use a standard bit if your main goal is to fine-tune or change the shape of a piece. With the grinder on and a good grip on the glass, use light, steady pressure to touch the edge of the glass against the bit. Keep the glass moving. If it sits in one place, you will keep grinding that one section.

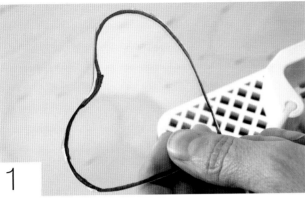

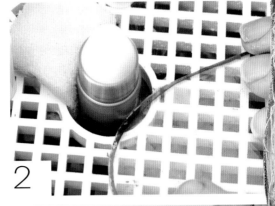

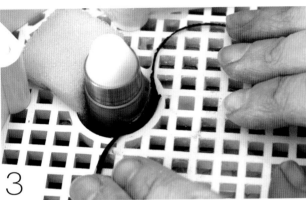

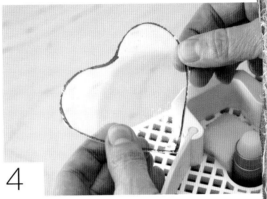

1 Grind away any glass on the outside of the marker line. If you look closely, right in the dip you will see the portion that needs to be ground away. This is how you fine-tune your pieces. If your cutting isn't where you want it to be, you can fix a lot of mistakes with the grinder.

2 Start with the grinder on. Using both hands move the piece back and forth until the area that you want to grind down is gone. Hold on tight and remember, keep the glass moving; if you leave the glass in one spot, you may grind into the shape.

3 Always grind away the points and areas that are on the outside of the marker line.

4 The finished heart shape. The more you practice your glass cutting, the less grinding you will have to do. This is something you have to practice. I still have to remind myself of this.

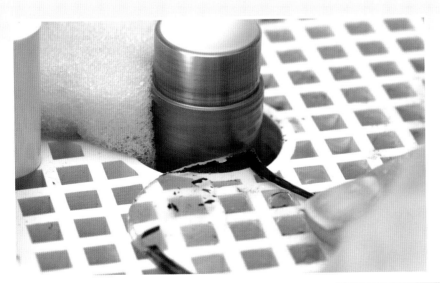

Here is another example with the bird shape. Same principles, different shape.

JEWELRY TOOLS

If you don't already have basic tools, you will need to add these jewelry essentials to your tool kit. They are readily available at your local craft or bead store and will not break the bank. My jewelry tools have a permanent home on my worktable.

Third hand

This is a handy device if you are having a hard time adding jump rings freehand. When you set up a third hand, it acts like a jig. It will suppress a lot of unnecessary frustration and earn your undying gratitude.

18-gauge nickel silver wire

Chain-nose pliers

They are smooth on the inside and will not mar your metal. I have two sets. I use them when opening and closing jump rings. Treat them like your only-for-cutting paper scissors. You want them to be scratch and nick free.

Double-barrel pliers

The perfect tool for making jump rings. Each barrel makes a different diameter circle. I have two pairs of double-barrel pliers. With a set of two of these pliers, you can make four different sizes of jump rings.

Jump rings

Jump rings come in a variety of sizes and metals. You can buy them premade or you can easily make you own. If I use Silvergleem solder, I use sterling silver store-bought 18-gauge jump rings. For anything else, I use 18-gauge nickel silver and make my own jump rings.

Flat linked chain

Chain can be used to suspend a pendant or wall hanging. I buy chain that can be used for both jewelry and decorative pieces and keep a variety of chains on hand.

Wire cutters

If you plan on making your own jump rings, you will need a basic pair of wire cutters. Since you solder the open end of the jump ring into the solder, don't fret over the obvious pinch when you snip off your jump ring.

Ball chain

This is an ideal match if you want a simple chain for a soldered charm, and it's an easy way to add a decorative beaded edge to your pieces.

••• JUMP RINGS

Materials

- 18-gauge nickel silver wire
- Double-barrel pliers
- Wire cutters

1. With the double-barrel pliers, grasp the wire at the end of the barrels.

2. Next, rotate the pliers to form a circle.

3. Continue turning the pliers to form more circles behind the first circle. Keep feeding the wire behind each circle. Open and close the pliers as if you are taking small bites and rotate the pliers away from you at the same time.

4. The hand holding the wire never moves. Just open and close the pliers to feed the wire in.

5. Once you have made your coil, remove it from the pliers. Snip off the leftover wire.

6. Using wire cutters, snip off one jump ring at a time. Don't worry about the pinch in the jump ring because you will be soldering the jump ring open-end down.

7. These are a couple of the different jump rings used in this book.

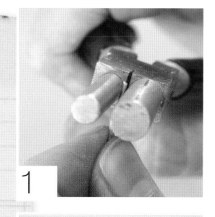

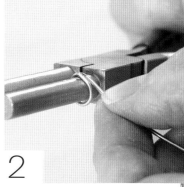

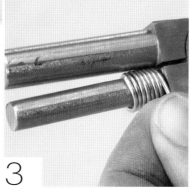

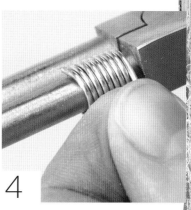

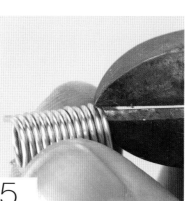

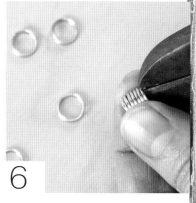

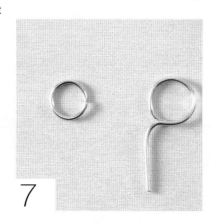

➤ Before jumping into the projects, it is important to understand the purpose of tinning your piece, which is not to be confused with tinning your iron tip. Tinning is when you apply a layer of solder on the front and back of your piece in order to build a round beaded edge. It is the beginning step for most soldering projects. You will tin the front, turn the piece over and then tin the back. Don't worry about any drips that occur during the tinning process, as you will use those to build your beaded edge.

➤ Solder is self-leveling, so always work parallel to your workstation.

➤ If you drag your iron, you will end up with a thin layer of solder, which is not desirable. For most of the soldering process, you are not dragging, but rather pulling a bead of solder along the copper edge or using a tapping motion to build a rounded edge. Do not get in the habit of dragging your iron across your beaded edge; the only thing you will accomplish is pushing a ball of solder onto the other side.

➤ If you tap too sporadically, you will end up with a wavy side.

➤ If you do not let your solder dry all the way through before moving, your edge will end up with ripples.

➤ Cross-locking, self-clamping tweezers come in handy when handling small pieces.

➤ Solder is extremely forgiving. The hardest part is learning how to be patient and forgive yourself if you mess up. The only way to get over your frustration is to practice. There are no shortcuts.

➤ Whenever you try to fix something minimal that is bothering you, ninety percent of the time you will end up making more of a mess and having to fix something else.

➤ It's handmade—it's not going to be perfect!

➤ As you work, clean your iron on the sponge. Make this a habit. You want your tip to be shiny.

➤ If you try to fix a jump ring without holding it with the tweezers, heating the solder next to it will cause the jump ring to fall over. Don't panic—this can be fixed.

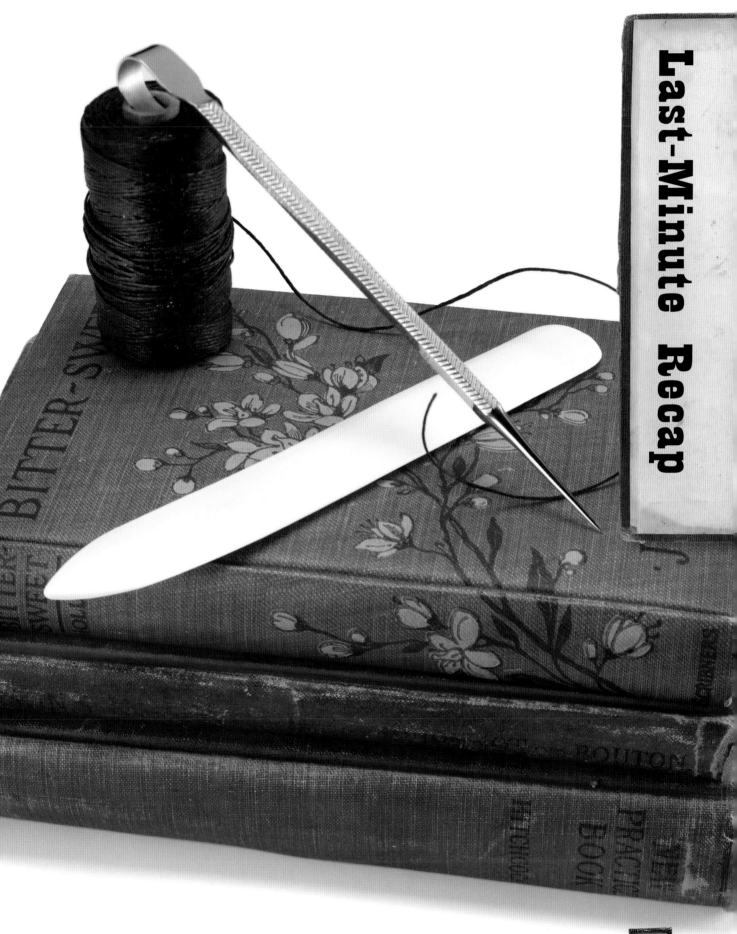

The basics of soldering that we have covered apply to all of these projects, no matter what size or shape.

There's a toggle-clasp pendant that, while it has a significant number of steps, is a great reference for utilizing your newly honed skills. We'll make a basic plaque that uses tea-stained tea bags as an image surface, and another that features vintage doilies and textiles using iron-on decals and needlepoint. We'll explore dimensional soldering by creating a shadow box bunting with found objects as the focal point. We'll build an eyeglass-lens pendant, like a domed-glass frame, to showcase a keepsake. We'll use the lens cutter for a ball chain picture frame and make our own fonts using a technique called *tack soldering*. And the book project combines imagery, glass drilling and bookbinding.

Taking our soldering skills a step further, we will venture into more structured work. We'll blend found objects with geometric shapes to create a freestanding pencil house. A small flightless bird will become an airborne image display with structural form and a simple jump ring. These pieces naturally expand to include work with found objects, personal ephemera and textiles.

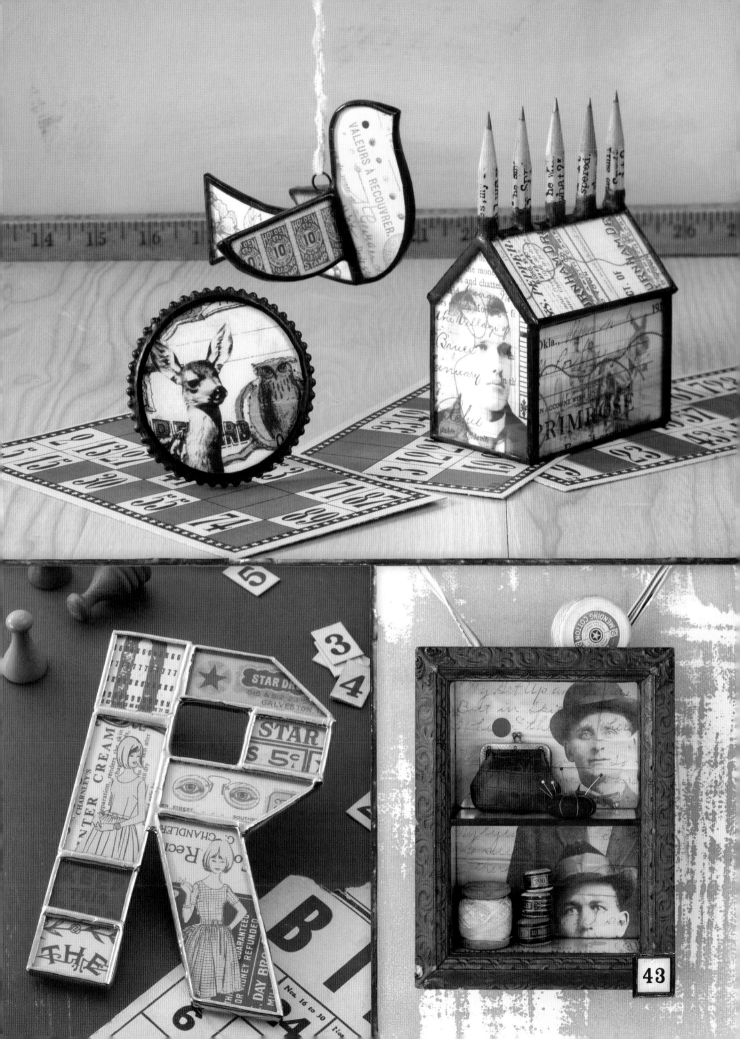

Materials

- Basic soldering tool kit
- Solder, Silvergleem
- Copper foil tape, cut to size
- 2 panes for the pendant (size is up to you) and 1 piece for the toggle (size 5/16" × 1¼" [8mm × 32mm])
- Collage, embroidered fabric or ephemera
- Scrapbook paper

- Glue stick
- White copy paper
- Scissors
- Sharpie
- 18-gauge sterling silver wire
- 3/16" (5mm) store-bought sterling silver jump rings
- Two ¼" (6mm) store-bought sterling silver jump rings

- Sterling silver linked chain
- Pair of chain-nose pliers
- Wire cutters
- Rubber gloves
- Polishing compound
- Cotton swabs

Optional: Third hand

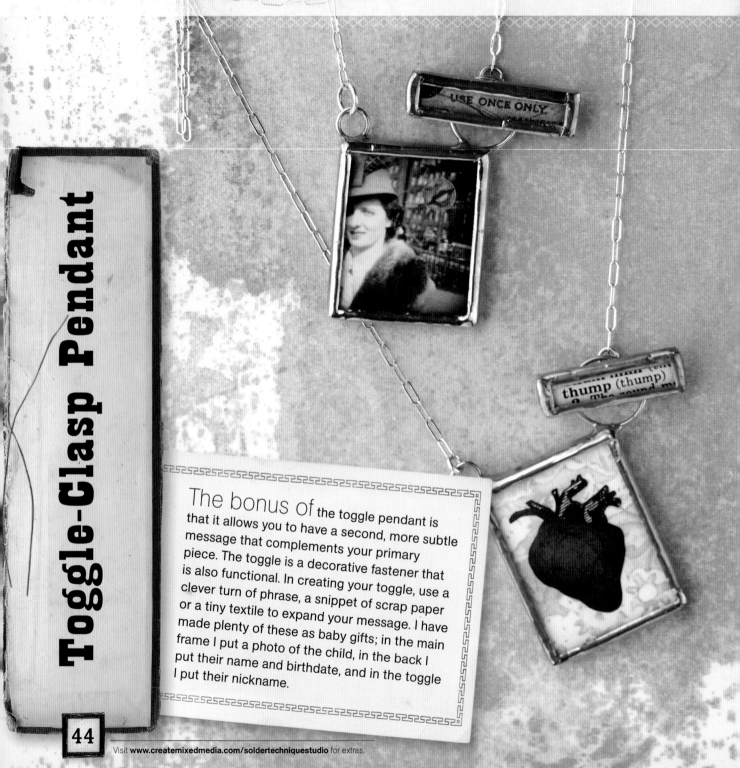

Toggle-Clasp Pendant

The bonus of the toggle pendant is that it allows you to have a second, more subtle message that complements your primary piece. The toggle is a decorative fastener that is also functional. In creating your toggle, use a clever turn of phrase, a snippet of scrap paper or a tiny textile to expand your message. I have made plenty of these as baby gifts; in the main frame I put a photo of the child, in the back I put their name and birthdate, and in the toggle I put their nickname.

Visit **www.createmixedmedia.com/soldertechniquestudio** for extras.

1

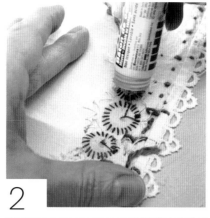

2

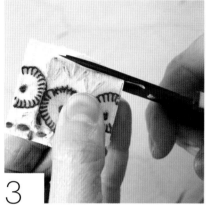

3

4

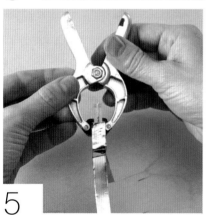

5

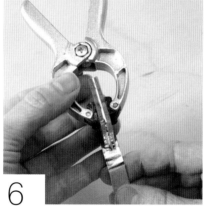

6

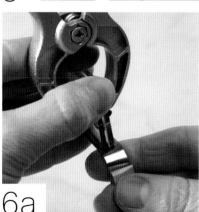

6a

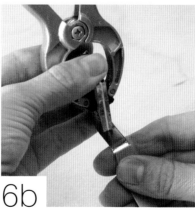

6b

1 Use a piece of precut glass as your composition guide. Trim your image with a craft knife. If you are not comfortable using a craft knife, hold the image to glass and use scissors to trim off excess paper. Even when using a craft knife, I still hold the paper to the glass and trim off any paper sticking out beyond the edge of the glass.

2 Apply glue over the back of an embroidered piece of your choice. This will help to keep the stitches in place. Put a piece of white copy paper on top of the glue to reinforce the textile and stitches.

3 Place a piece of precut glass over the embroidered textile and cut down to size.

4 You will need two pieces of clean glass, two images cut down to size and copper foil tape cut down to size.

5 Sandwich the embroidered piece and image between two panes of glass. Now, determine the width of the copper foil tape by clamping the embroidered piece, image and two panes of glass. Place the clamped piece in the middle of different widths of copper foil tape, and choose a width that will overlap the front and back approximately a couple millimeters. Measure around the perimeter of the glass with the copper foil tape. Leave enough to overlap approximately ¼" (6mm) at the end. Trim down as necessary.

6 Keeping the piece squared up, move the clamp so it faces away from you. Start the copper foil tape along the bottom center of the piece (do not start on a corner). I prefer to start wrapping my copper foil tape on the opposite end of where I am going to attach my jump ring. If you are going to attach jump rings to the top and bottom, start on the side. If you are attaching four jump rings to one piece, it doesn't matter where you start as long as it's not a corner.

6a The piece now sits in the middle of the copper foil tape.

6b Once you have the tape started on the bottom center of the piece and the glass is aligned

TIP If you have copper foil tape that is too thin and the next size up is too thick, trim down the larger size.

45

in the middle of the tape, place your thumb on top of the piece and your fingers on the bottom, preparing to rotate the piece clockwise as you affix the tape around the edges of the glass. Remember: do not hold the clamp. Always have the paper backing and adhesive of the copper foil tape facing you, and always position your hands with a thumb on the top and fingers on the bottom.

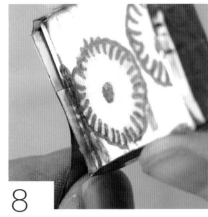

7 Peel away more backing. Gently pull the copper foil tape taut and place the corner of the piece in the middle of the copper tape. Peel away more of the backing. Reposition your hands (thumb on top, fingers on the bottom) and move the clamp so it is facing away from you and rotate the corner into the middle of the copper tape. Again, gently pull the tape taut and place the next corner in the middle of the copper tape. Repeat until you have two and a half sides wrapped. Always reposition your hands with your thumb on top, fingers on the bottom, and the clamp facing away from you. After two and a half sides have been wrapped, you can take the clamp off.

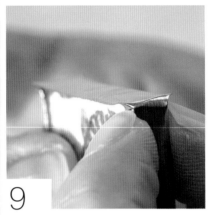
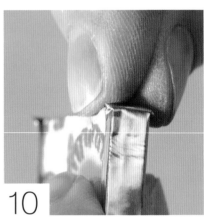

8 Once you get to the end, even out the edges and overlap about ¼" (6mm) and trim off the excess. If you always have the adhesive side of the tape facing you, you will always see what you are doing. Move at a strategic pace and you will get a more centered wrap, with even amounts of tape on each side.

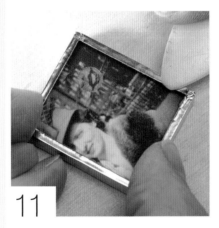
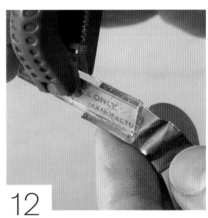

9 With both fingers, push the sides of the copper foil tape down and tuck under at the corner, then overlap what you just tucked under. Continue to work your way around the piece tucking and pinching.

10 Repeat step 9 on the other side.

11 Burnish with a bone folder until you get a smooth seal. Push the corners down; don't worry if they look smooshed, they will be covered with solder. Don't forget to burnish the sides and where

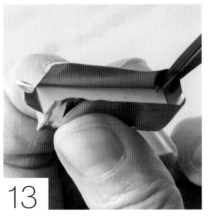
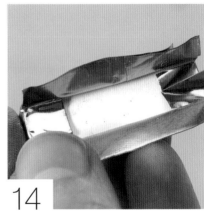

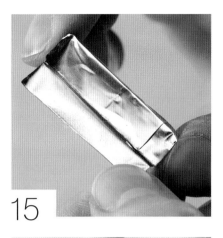

15

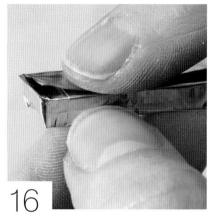

16

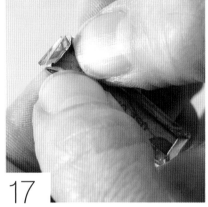

17

18

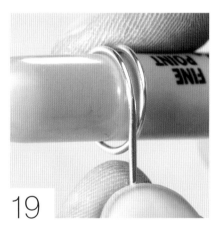

19

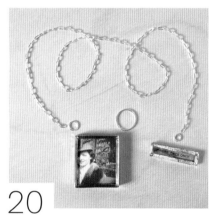

20

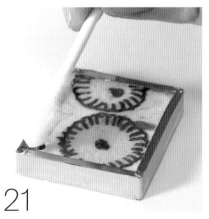

21

the copper foil tape overlaps. You are building the foundation of your piece, and it is important to get a good even wrap and a smooth tight seal on your burnishing.

12 The measurement for the piece of the toggle is ⁵⁄₁₆" × 1¼" (8mm × 32mm). Cut a piece of decorative paper accordingly. Use a small clamp to hold the paper to the glass. Using ½" (12mm) wide copper foil tape, place the glass approximately ¹⁄₁₆" (2mm) down from the top edge of the copper foil tape. Place the end of the tape at the center of the long edge of the glass. Wrap the copper foil tape around the glass and overlap approximately ¼" (6mm) at the end.

13 Use fine-tip scissors to notch the four corners. You will have four flaps on the back.

14 Fold down the two shorter notched pieces.

15 Fold down a long side of the copper foil tape with the overlap.

16 Fold over the last long piece.

17 Pinch, tuck and overlap the copper foil tape on the front. Burnish.

18 Trim excess copper foil tape.

19 Wrap a piece of 18-gauge sterling silver wire around a Sharpie marker. Make a single coil. Use wire cutters to nip off one jump ring.

20 The photo shows the jump ring layout. You are now ready to solder. Clean up your workspace and plug in your iron. The ¼" (6mm) and large-diameter jump rings will go on the pendant and a ³⁄₁₆" (5mm) on the back of the toggle.

21 Using a cotton swab apply a thin layer of gel flux to the front, back and sides.

47

22 Note: use the length of the Silvergleem solder coming off the roll to hold the piece in place while soldering and start by tinning the front and back of the piece. Once your iron is heated to the right temperature, pick up a bead of solder with your iron tip. Position the bead on the top edge of the copper foil tape. Once it starts to melt onto the copper foil tape, pull the solder along the edge of the tape in one fell swoop. Do not use your iron like a paintbrush. If you don't have enough solder to finish one edge, get another bead. Start where you left off and melt the solder together, then pull the bead along the edge of the tape.

22a Fight the urge to fix any drips. Use cross-locking, self-clamping tweezers or a gloved hand to turn the piece over and tin. Work in a systematic way and continue tinning the other side.

22b If your piece looks like this, you are on the right track. Trust me. Fight the urge! You can do it.

23 Use cross-locking, self-clamping tweezers and get ahold of your piece. Place it on its edge parallel to your soldering surface. Apply a layer of flux over your solder. Start off by tapping out the existing solder. Melt all the way through from the front to the back (see iron placement in photo). Do not drag the solder along the top. Use a tapping motion, melting all the way through the drips of solder. Once you get to the end of an edge, pick up your iron. Do not push a bead of solder onto the next edge. Hold still until the solder dries all the way through. Once dry, open the cross-locking, self-clamping tweezers and repeat on the next edge. Make small, slow taps right next to each other in order to melt all of the solder together.

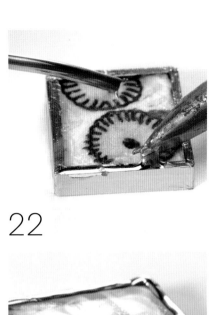

22

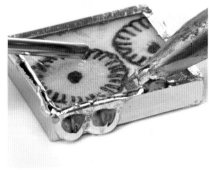

22a

22b

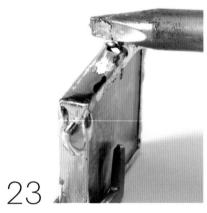

23

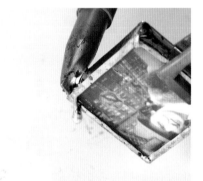

24

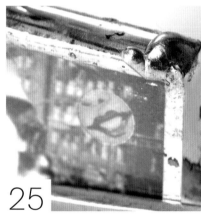

25

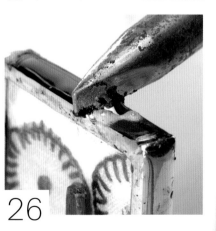

26

TIP

If you want a more rounded edge, apply flux, pick up a bead of solder, melt it to the solder that's already on your piece and tap it out.

Visit **www.createmixedmedia.com/soldertechniquestudio** for extras.

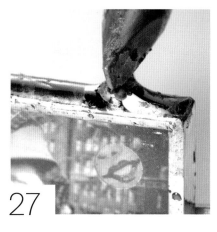

27

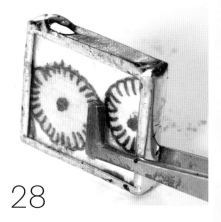

28

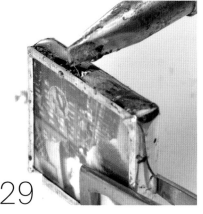

29

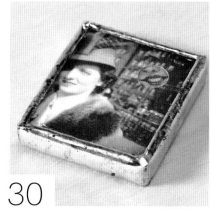

30

31

32

24 Steps 24 through 30 are how to fix mishaps. If you add too much solder on your edge, you are going to melt and drag the solder off. Yes, I said drag it off, as there are instances where you have to drag. Be careful of any drips that fall off—they are very hot!

25 If you get a lump from pushing solder from the other side, add a little bit of flux and melt it into the next edge, keeping in mind to melt the solder all the way through. Tap out the extra solder.

26 If you did drag your iron and you don't have a nice rounded bead, apply a layer of flux and add more beads of solder. Again, don't forget to tap from the front to the back and melt it all the way through.

27 Notice the iron hovering above the solder and the whole area melted all the way through.

28 If you move your piece before the solder has dried all the way through, you will end up with a ripple effect or all your solder will roll down to one side. Gravity will come into play: liquid travels downhill.

29 Add flux and tap it out.

30 Notice that it's not perfect, but you have to learn how to step away.

31 Now it is time to make the toggle. Begin by tinning the copper foil tape that is burnished to the front of the glass toggle. Apply flux before you begin soldering and throughout the soldering process. Using cross-locking, self-clamping tweezers, turn the piece over, apply flux to the back and add multiple beads of solder to the back to create a domed edge.

32 Apply flux and tap out the edges of the sides. Notice how to position the cross-locking, self-clamping tweezers. Remember to let the solder dry all the way through before moving your piece.

TIP
If you find yourself getting frustrated, step away. You can always go back and work on it later. I can't stress enough that you shouldn't fret; know when it's time to stop and move on to the next piece. With each piece you can only get better!

49

33 Next, we will add the ³⁄₁₆" (5mm) jump ring to the back center of the toggle. Take the jump ring and grasp it with your cross-locking, self-clamping tweezers, open-end down. Apply flux to the open end of the jump ring and a bit to the area where you want to add the jump ring.

34 Use your iron to melt the solder where you want to affix the jump ring. Push the jump ring into the heated solder while holding it still. Apply the iron to either side of the jump ring to melt the solder all the way down so the jump ring sinks as low as it can go. Tap out the edges on either side of the jump ring. Hold the piece still until it cools.

35 Steps 35 through 41 show to set-up your workspace when affixing multiple jump rings and how to fix common jump ring mishaps. Using two clamps, secure the piece at the top.

36 Push the clamp arms down towards the table to make a stable work station so the clamp arms serve as angled braces. It's important to have a stable piece; if your piece moves, it's hard to add your jump ring.

37 As an option when adding your jump rings, you can use a third hand. This is very helpful if you tend to be shaky or have an unsteady grip.

38 Using the cross-locking, self-clamping tweezers, grasp the jump ring open-end down, apply flux to the open end and a bit where you want to attach the jump ring. Place the jump ring open-end down on the piece where it will be soldered. Steady your hand while holding the jump ring in place.

39 Get a small bead of solder, go in on the side and melt the existing solder to the new bead, keeping the jump ring steady. Repeat on the opposite side of the jump ring. If needed, tap out the top on either side. Keep your hand still until the solder cools. When the

33

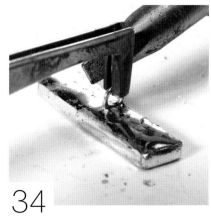

34

35

36

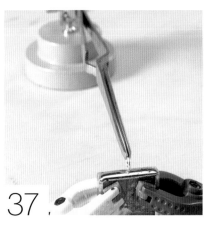

37

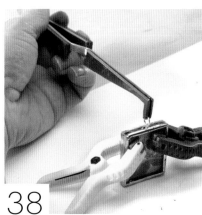

38

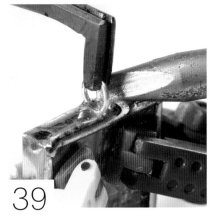

39

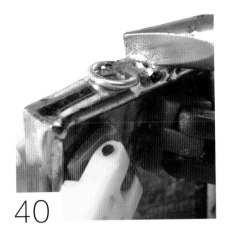

40

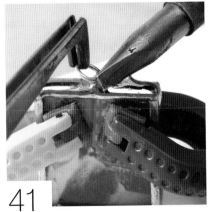

41

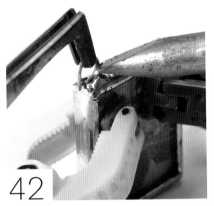

42

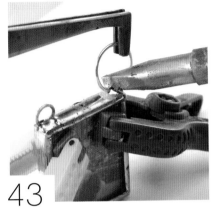

43

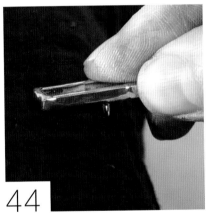

44

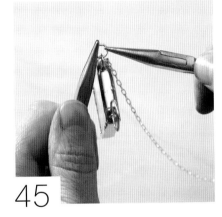

45

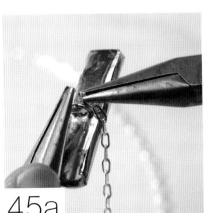

45a

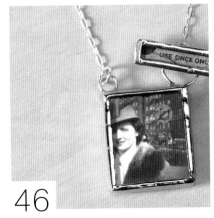

46

solder has cooled, release the jump ring from the tweezers.

40 If you try to affix the jump ring without holding it with the tweezers, heating the solder next to it will cause the jump ring to fall over. Don't panic—this can be fixed.

41 To remove a fallen jump ring, grasp the jump ring with the tweezers, heat up the solder around the jump ring and pull up the jump ring out of the solder. Add flux and tap the top out again.

42 We will now add jump rings to create the toggle necklace. Apply a ¼" (6mm) jump ring to one end of the piece.

43 Affix the larger Sharpie jump ring on the opposite end.

44 Clean the piece with flux cleaner or alcohol, using paper towels. Do not spray the piece—spray the cleaner onto the towel. After cleaning and removing flux, use a polishing compound to give the piece a pleasing shine. For an even polish, place your towel on the table and hold it in position, rubbing the piece across the surface of the towel. To polish the area around the jump ring, move your towel to the 90-degree edge of the table and rub your piece back and forth around the jump ring.

45–45a Use chain-nose pliers to attach a flat drawn sterling silver cable chain to the piece and the toggle.

46 Thread the toggle piece through the jump ring made with the Sharpie.

51

Materials

- Basic soldering tool kit
- Solder, 60/40
- Black-backed copper foil tape, cut to size
- Glass, cut to size
- Lipton-steeped black tea bags (emptied and ironed flat, enough to cover 8½" × 11" (22cm × 28cm)
- Freezer paper 8½" × 11" (22cm × 28cm)
- An assortment of vintage ephemera
- Inkjet copier/printer
- Iron and ironing board
- PanPastels and applicator
- Sewing machine and thread
- Double-stick tape
- Circles that protect the shipping tag hole
- Stamp (Stampers Anonymous)
- Ink pad
- Pencil shavings
- Jump rings
- Piece of scrap glass
- Chain
- Rubber gloves
- Novacan Black Patina
- Cotton swabs

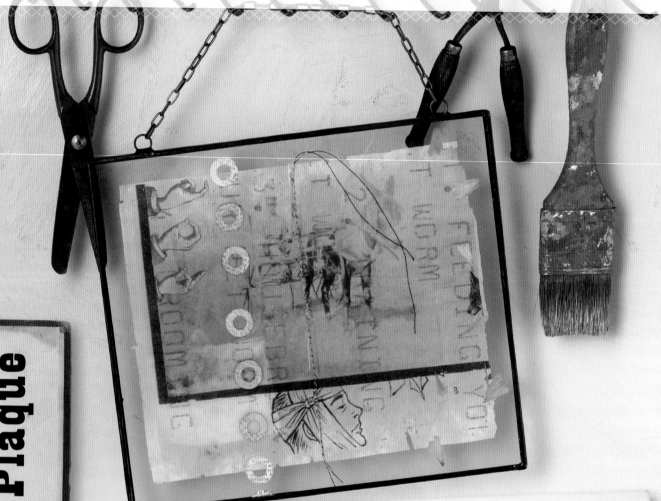

Tea Bag Plaque

The lovely, natural tint of stained tea bags and their transparency are a perfect surface for transferring images. Because of the cloth-like transparent intrinsic value of the tea bags, they make a perfect canvas for soldering in between two pieces of glass. Printing on repurposed tea bags is not a new technique, but printing on one tea bag at a time can be limiting. The beauty of the technique is that you can cover a whole sheet of paper with tea bags and transfer large-scale images. You can also mix and match images from different transfers for more interest. As a bonus, you can sew them together without tearing. For added depth and texture, I carefully chose found objects that didn't add any physical dimension, like pencil shavings.

Visit **www.createmixedmedia.com/soldertechniquestudio** for extras.

1

2

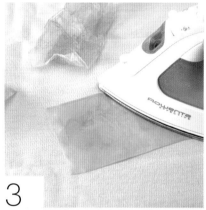

5

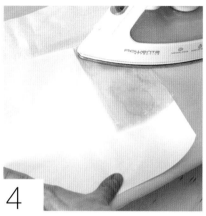

8

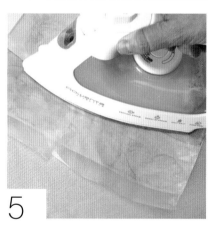

4

1

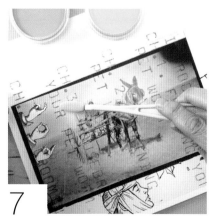

3

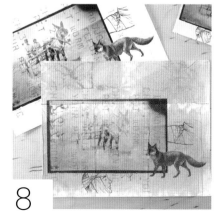

6

1 Tea bags must be completely dry before storing them away or they become moldy.

2 Open up the tea bags and wipe away any stray remaining tea. You can compost the tea.

3 Iron tea bags flat.

4 Tea bags need a substrate for them to run through your printer. Iron the tea bags onto the waxy side of the freezer paper.

5 Use the cotton setting on your iron. With the freezer paper wax-side up, iron the tea bags one by one onto the freezer paper until the whole surface is covered. Trim off the portion of the tea bags that hangs off the edge of the paper. Try not to iron the paper if there is no tea bag covering it because it irons the wax away.

6 Now work on your image that will be copied to your tea bag covered freezer paper. I like to collage a base image using old photos and random ephemera. I begin the collage by placing ephemera or random images on the copy machine. I then play around with the enlarge setting on the printer, starting at 400% and press "Copy." Then I place the copied page back into the printer feeder and change the ephemera on the copy machine, change the enlarge setting and again hit "Copy." I will keep repeating this process until I am happy with the final image. The best part is you never know how it's going to layer.

7 PanPastels are chalks that are a great way to add color and definition to the final image. Once you have your final image, place that on the copier.

8 Copy the image onto the tea bags by sending the ironed tea bag freezer paper sheet through your printer. Let the ink dry for a few minutes.

9　Carefully peel the printed tea bags from the freezer paper. If they get stuck, try pulling from the other side against the rip. If there is a little bit of a tear, don't worry; it will add character to your piece.

10　You can create a variety of looks using this tea bag printing technique. Once you have all your pieces ripped off, you can determine which pieces make the best composition. You can use different pieces from different collages.

11　I decided to go with the two pieces without the fox because the fox was such a darker image than the rest of the composition that your eye immediately went to the fox versus the whole composition.

12　Sew the pieces together and iron again.

13　To add texture and other elements to the piece, you can use ephemera or found objects; just make sure that they are thin. Get creative and think outside the box of a found object's being three-dimensional—look around to see what is flat that has texture. For these circles, I used shipping tag hole protectors which come off the tags. I then stamped them to add text.

14　Play around with different textures and gather your pieces to put together your collage. Here are used pencil shavings, shipping tag circles and leftover strands of thread from the sewing to add another layer of color.

15　Cut the glass to the appropriate size; I left about a ½" (12mm) border around the edges. Clean the glass using a good-quality paper towel or microfiber towel that doesn't create a lot of lint. Once the glass is clean, use a small piece of double-stick tape and tape the composition to

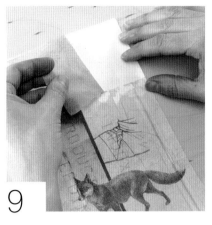
9

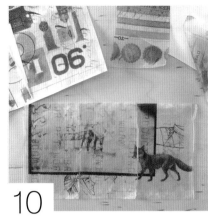
10

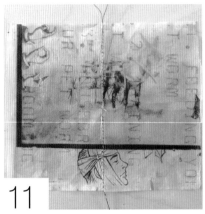
11

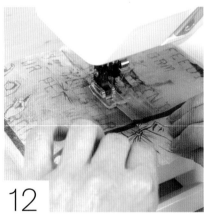
12

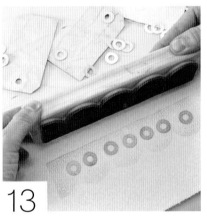
13

14

15

16

Visit **www.createmixedmedia.com/soldertechniquestudio** for extras.

17

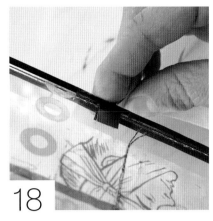

18

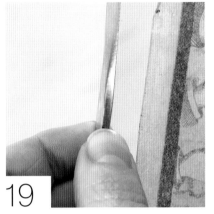

19

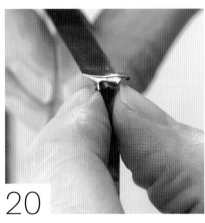

20

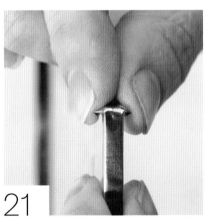

21

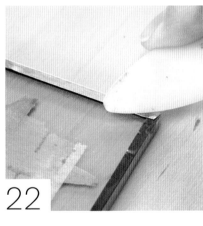

22

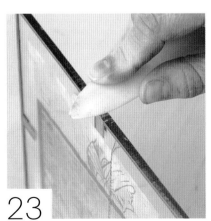

23

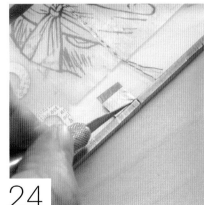

24

the glass. You don't need a lot of tape—just enough so your work doesn't slide around. I like to leave the string that is left over from the sewing machine so it becomes part of the collage. Once you find the composition that you want, go ahead and clean the second piece of glass. Place the glass clean-side down on top of the collage. Clamp your pieces using clamps with rubber edges. Square off the glass.

16 Cut pieces of copper foil tape 2" (51mm) in length. Affix them to the midpoints of each side and then remove the clamps. When choosing the right thickness of copper foil tape to go around the perimeter, keep in mind that the tape needs to wrap over the front and back of the glass a few millimeters. I chose black-backed copper foil tape in a ⅜" (10mm) width because you can see through the glass, and I feel it gives a more finished look.

17–23 Refer to the copper wrapping found in the *Toggle-Clasp Pendant* project, steps 12–18.

24 Use the craft knife and the edge of the copper foil tape as guides, and trim off the copper foil tape tabs.

TIP

When soldering make sure your work area is clutter-free. For most of the projects in the book, I work on a piece of foam core, which isn't fireproof. For bigger projects I recommend a fireproof work surface.

55

25 The first step in soldering is to apply flux to the top edge and sides.

26 Then tin the copper foil tape. Tinning is laying down a thin layer of solder over the copper foil tape. Pick up a bead of solder, place the tip of the iron on the copper foil tape and pull it down on top of the copper foil tape until you run out of solder. Pick up another bead and repeat on the front and back of the piece.

27 Another way of running the bead is by holding the iron and a length of solder together, and running them down the copper foil tape simultaneously. When the first side is cool, turn your piece over and tin the other side. Finish off by soldering the perimeter.

28 Here we have another example of tinning.

29 To solder the perimeter edge, clamp the piece as shown. If the piece gets too hot or you are sensitive to heat, wear utility gloves for this process. I use big clamps to stabilize the piece.

30 Because this is more of a frame, we are not concerned with making a rounded or domed-edge bead like you would on a piece of jewelry. Remember to make sure to melt all pieces of solder together or you get lumps. Tap from the front to the back.

31 You will still apply the same soldering techniques, only in this case it's more about a finished effect that complements your artwork. If your solder isn't melting together, apply a thin layer of flux. You will be adding flux throughout the soldering process and can apply it on top of solder at any point. By tapping out the top you effectively even out

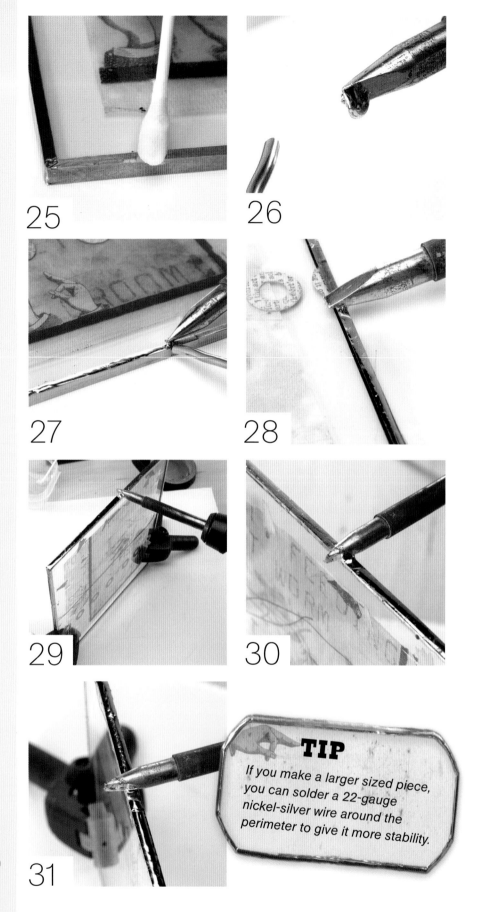

25

26

27

28

29

30

31

TIP
If you make a larger sized piece, you can solder a 22-gauge nickel-silver wire around the perimeter to give it more stability.

Visit **www.createmixedmedia.com/soldertechniquestudio** for extras.

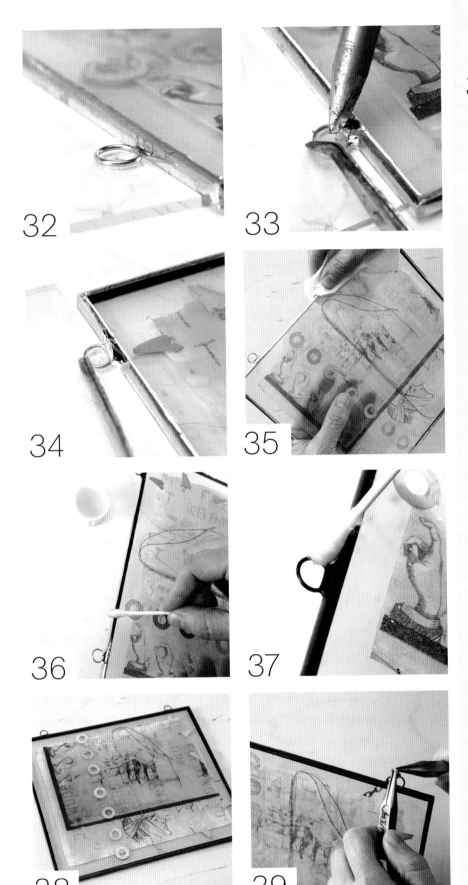

the bumps from the front and back sides.

32 To solder jump rings on larger pieces, use a single piece of glass as a jig. Place a piece of glass right up against the finished soldered edge and place a bit of flux where you want to attach the jump ring. With your jump ring open-end down, apply a small amount of flux. Set the ring on the glass and place the open end against the soldered edge.

33 Using cross-locking, self-clamping tweezers to hold the jump ring in place, pick up a bead of solder and place it in the center of the jump ring, then melt it together with the soldered edge.

34 Repeat on the other side.

35 Clean the solder and remove any flux residue. Don't worry about cleaning the glass at this point.

36 The soldered surface is now ready to patina. Pour a small amount of patina in the cap of the patina; never insert a dirty cotton swab inside the patina bottle as you will contaminate the patina. Always pour it into a separate container; I like to use the cap because it is small and convenient.

37 Patina the solder all the way around and the jump rings.

38 Note that the patina dries quickly.

39 Add your chain or handle, clean the glass and your piece is complete!

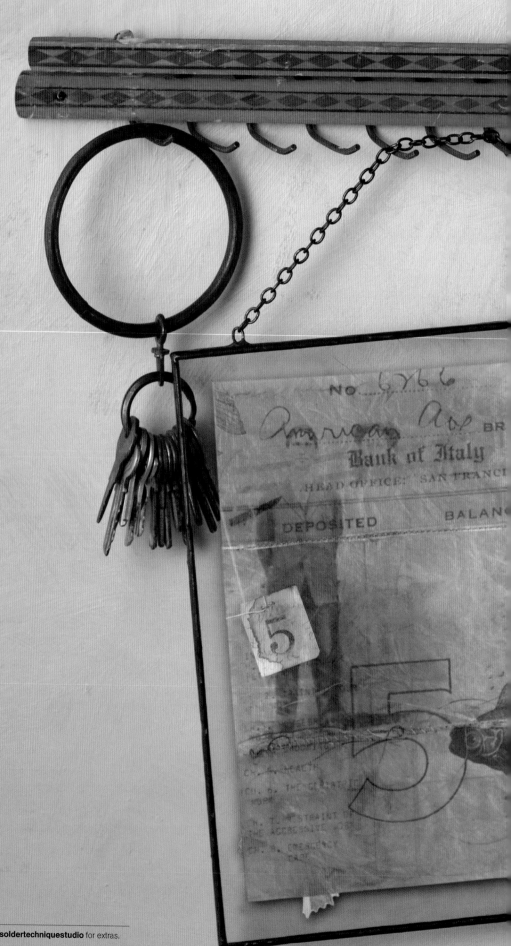

Visit **www.createmixedmedia.com/soldertechniquestudio** for extras.

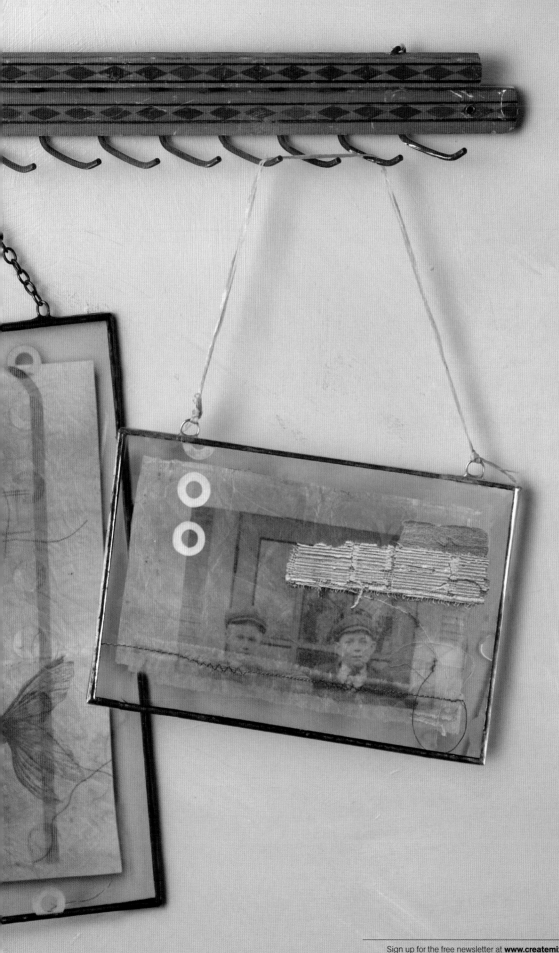

Materials

- Basic soldering tool kit
- Solder, 60/40
- Black-backed copper foil tape, cut to size
- Image transfer paper
- Vintage fabric pieces (quilt, doilies, apron)
- Embroidery threads
- Pencil
- Sewing machine and thread
- Scissors
- Needle
- Rubber gloves
- Novacan Black Patina
- Cotton swabs
- Scrap fabric for hanger

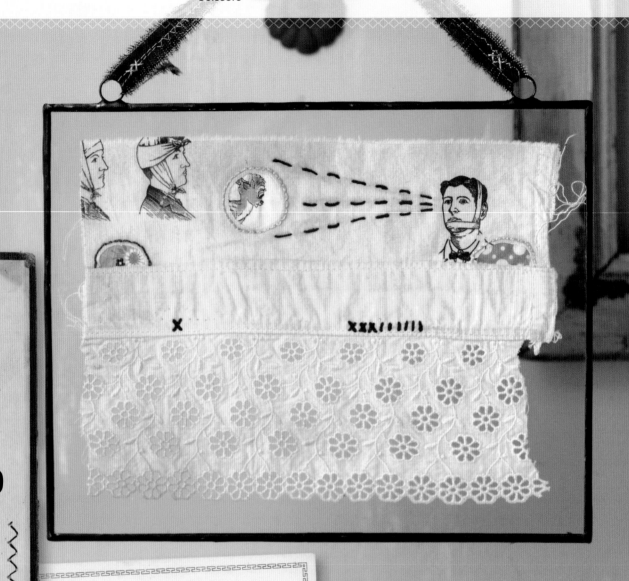

Just the Right Size

By repurposing vintage doilies and incorporating some basic needlepoint, appliqué and iron-on fabric transfers, this project is a great collaboration of soldering and textile crafting.

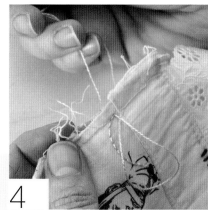 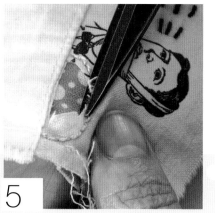

1. Select a base fabric for your reverse appliqué piece. Suggested fabrics include a vintage doily, older printed tablecloth, older needlepoint tablecloth or lace-edged sheets, and a variety of colors of needlepoint thread. The images that you see on the sample were made using iron-on heat transfer. Follow the manufacturer's instructions to create your transfer. This composition will be enhanced with appliqués, to build an interesting story to your piece.

2. Select the area of your composition that will feature your appliqué. It can be any shape you wish. In the sample shown at the end I used circles and half-moon shapes. Using a pencil, lightly trace your appliqué line onto your composition.

3. Choose a piece of decorative fabric and needlepoint thread that will show through and become part of your composition once you create the appliqué. This piece needs to be larger than the shape you've drawn on your composition. Place the decorative fabric on the backside of your pencil-drawn shape.

4. Hold or pin the fabric in place and, using a straight backstitch, stitch along the pencil-drawn line until you've fully outlined your shape.

5. Once you've completed your outline appliqué stitch, cut out the top layer of fabric from your composition to expose the decorative fabric below. I find that Tonic shears work great for removing the fabric. Make sure to cut within the interior of the stitching line to expose the decorative fabric.

6. Repeat the previous steps until you have achieved the desired effect. Using other decorative needlepoint stitches is a great way to add more interest and texture. You could look online for stitch samples and ideas. For the assembly instructions, follow steps from the *Toggle-Clasp Pendant* project to position the piece between glass and add hardware such as jump rings.

7

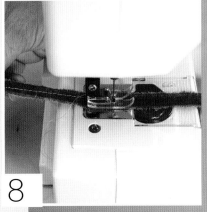

8

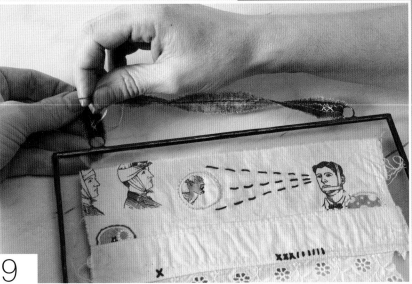

9

7 To create a fabric handle for the plaque, snip into a heavyweight fabric and rip the length of your desired handle. Remember to pull all the stray threads from the fabric piece.

8 Usually when I sew my handles, I change the stitches from straight to zigzag.

9 Once you have your handle inserted on the plaque, stitch back through the handle to add an additional thread color for aesthetics and to reinforce the handle.

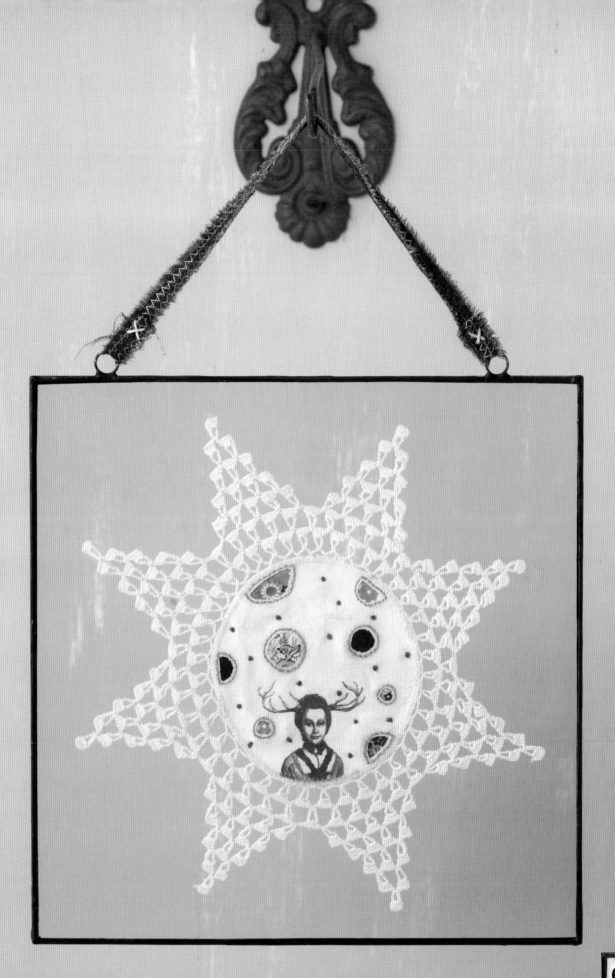

Materials

- Basic soldering tool kit
- Solder, 60/40
- 36-gauge aluminum flat sheet, cut to glass size
- Cuttlebug
- Alphabet embossing plate
- Utility or Tonic shears
- 2 pieces of triangular glass, cut to size
- Black-backed copper foil tape, cut to size
- StazOn re-inker, Teal Blue
- Heat gun
- Fine-grit manicure sanding sponge
- Old ruler
- Jeweler's saw or hacksaw
- Craft glue
- Rubber gloves
- Novacan Black Patina
- Cotton swabs
- Safety pins

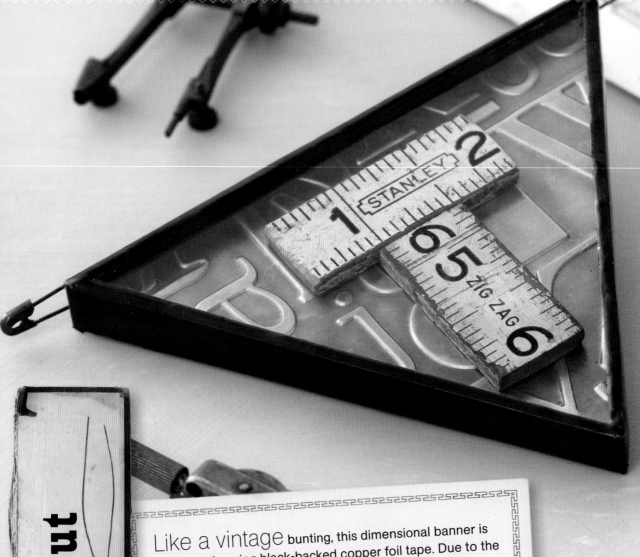

Side Out

Like a vintage bunting, this dimensional banner is easily made using black-backed copper foil tape. Due to the size of the found objects and the width of the copper foil tape, it is not necessary to build a separate box to house the objects. The black-backed copper foil tape adds a sense of depth and gives the appearance of a shadow box. The textured aluminum background under the T is made using the Cuttlebug and accompanying embossing plate.

Visit **www.createmixedmedia.com/soldertechniquestudio** for extras.

1

2

3

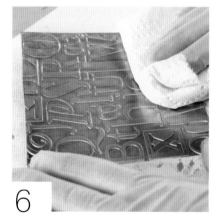

4

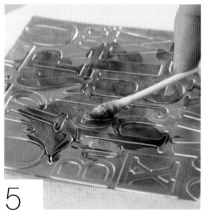

5

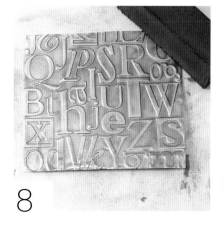

6

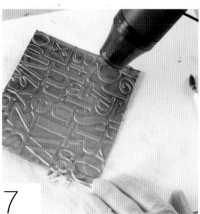

7

8

1 Determine the size of the banner and cut out two pieces of glass. Cut a piece of aluminum sheeting larger than the piece of glass.

2 Use a fine-grit manicure sanding sponge and sand the aluminum sheeting.

3 Using the Cuttlebug and an embossing plate, emboss the aluminum sheet. Follow the manufacturer's instructions.

4 Add a transparent layer of color to the aluminum sheeting. I like to use StazOn re-inkers.

5 Using a cotton swab, spread the ink around until the whole surface is covered.

6 While still wet, use a paper towel to even out the ink.

7 Use a heat gun to set the ink.

8 Using the fine-grit manicure sponge, sand off the embossed patterned layer of the aluminum sheet. Sand until you have achieved your desired effect.

9 Using your glass as a template, trim the aluminum sheet down.

10 Next we will make the found object letter. I chose to use an old ruler and used a jeweler's saw to cut the ruler down to size to make the letter "T".

11 Use glue to affix the ruler pieces on top of the embossed cutout aluminum sheeting.

12 Clean your glass and assemble the banner as follows: a piece of glass, aluminum sheeting with an affixed letter, and the top layer of glass. Clamp together. This is important; make sure that the clamp is always fastened onto the area that includes the found object.

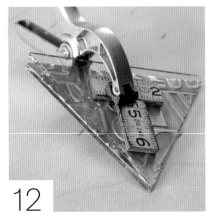

13 For this project I used ½" (12mm) black-backed copper foil tape. Measure the perimeter of the banner, add an extra ½" (12mm) and cut the length of the copper foil tape to overlap. With all the pieces clamped together and some of the backing peeled away from the tape, place the piece in the center width of the copper foil tape. You can start on any side, just don't start on a corner.

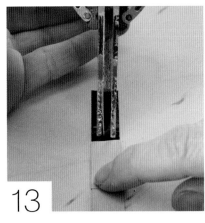

14 Adjust the clamp so it is out of your way, always keeping in mind that the clamp is fastened onto the area that includes the found object. Place a thumb on the top of the piece and a few fingers on the bottom. Then peel back more of the backing from the copper foil tape, gently pull or tug on the tape and rotate the corner down onto the center width of the copper foil tape.

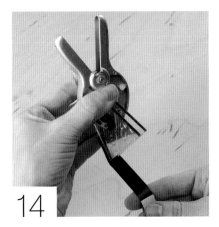

15 Reposition your hands with your thumb on top, fingers on the bottom and the clamp out of your way. Peel back more of the backing, gently pull on the tape and rotate the next corner onto the center width of the copper tape.

16 Repeat step 15.

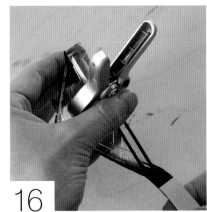

Visit **www.createmixedmedia.com/soldertechniquestudio** for extras.

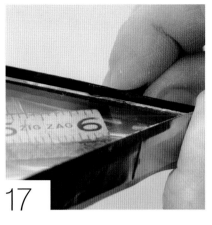

17

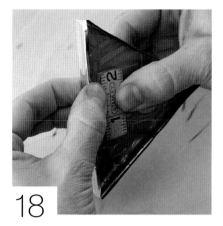

18

19

20

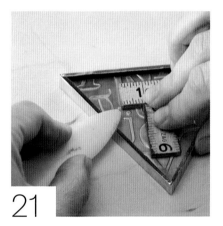

21

22

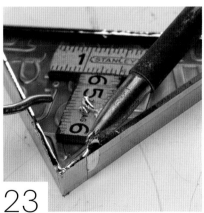

23

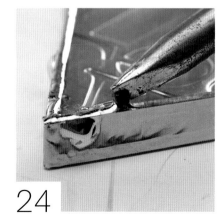

24

17 Once you get to the overlap, it's important that you even out the top and bottom edge of the copper foil tape and overlap approximately ½" (12mm).

18 When you are ready to pinch down the copper foil tape, always hold and apply pressure to the center of the piece on top of the found object. Simultaneously pinch down the top and bottom of the copper foil tape and affix it to the glass.

19 Still applying the pressure to the center, work your way down the edge, pinching the copper foil tape down until you get to the end.

20 Next, overlap the corner from the other side. Repeat this process, pinching, tucking and overlapping the corners until you have finished the piece. Always apply pressure on the found object to avoid collapsing the glass as you pinch the edge.

21 Next we will burnish. Using a bone folder, apply pressure to the center of the glass on top of the found object and burnish the edges of the copper foil tape. Turn the piece over and burnish the other side. Even though you can't see the found object from the back, you still need to apply pressure to the found object in the center because if you don't, the glass will collapse.

22 Burnish the outer edge, especially where the copper foil tape overlaps. Be careful not to puncture the copper foil tape.

23 Apply flux and tin the front and back edges of the piece. Use the solder roll as a tool to keep your piece from moving as you are soldering.

24 Don't worry if blobs of solder drip over the edge. We will use those to build the bead along the flat surface of the edge.

Sign up for the free newsletter at **www.createmixedmedia.com**.

67

25 Next, use clamps to brace the piece. Be sure to clamp and apply pressure on the found object until the piece is completely soldered. Create a tripod with the clamps, using the clamps as legs.

26 Run the solder along the flat edge of the side to fill in the flat surface of the copper foil tape and build a bead. The piece does get hot, so wear a glove on the hand that handles the project.

27 If you move your piece before the solder sets, you will create a wave effect.

28 If this happens, apply flux.

29 Tap it out, always heating up front to back and all the way through the bead of solder.

30 Continue running the solder along the two other sides.

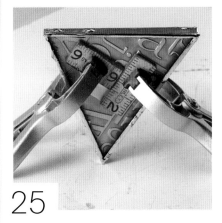

25

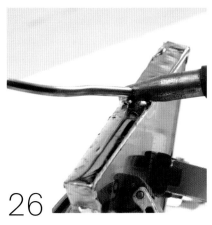

26

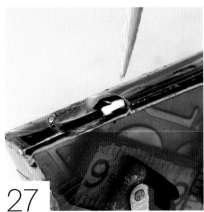

27

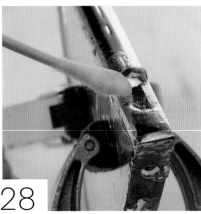

28

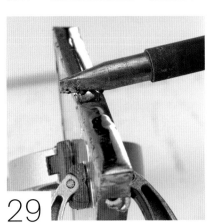

29

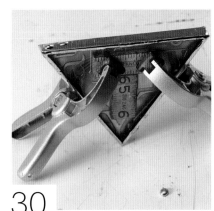

30

Visit **www.createmixedmedia.com/soldertechniquestudio** for extras.

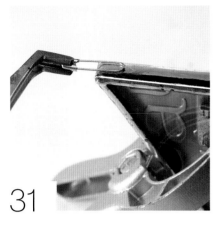

31

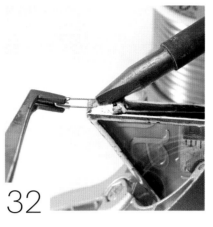

32

31 For a change of pace, we are going to add safety pins as hooks to string the pieces together. Apply flux where you are going to attach the safety pins, as well as to the ends of the safety pins.

32 Hold each safety pin steady with tweezers, pick up a bead of solder with your iron, melt the bead on top of the safety pin and melt it into the solder already there. Remove the iron, let the solder cool and release the tweezers from the safety pins.

33 Clean the piece and patina.

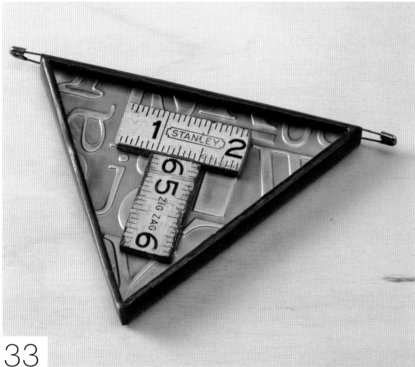

33

TIP

Don't forget to apply flux throughout the whole soldering process and to wipe your tip clean on a damp sponge as you solder. A clean tip is a happy tip! Never spray glass cleaner directly on your piece—always spray a paper towel or rag and then clean.

Sign up for the free newsletter at **www.createmixedmedia.com**.

69

AND HE WILL MEASL

Materials

- Basic soldering tool kit
- Solder, Silvergleem
- Copper foil tape, cut to size
- Eyeglass lens
- Bakelite buckle or found object of choice
- Vintage photograph
- Background paper

- Colored cardstock
- Glue stick, craft glue or double-stick tape
- Piece of mat board
- Sakura gel pen, Clear Star
- Aluminum flashing
- ⅛" (3mm) hole punch
- Utility or Tonic shears

- 4 sterling silver jump rings
- Chain-nose pliers
- Blow dryer
- Leather cord, ribbon or chain
- Polishing compound
- Cotton swab
- Fine-grit manicure sanding sponge

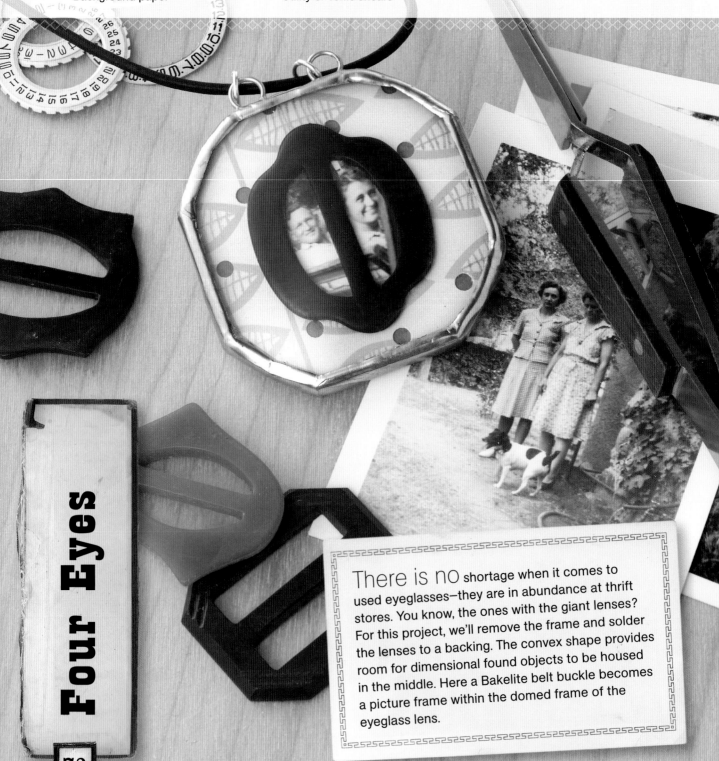

There is no shortage when it comes to used eyeglasses—they are in abundance at thrift stores. You know, the ones with the giant lenses? For this project, we'll remove the frame and solder the lenses to a backing. The convex shape provides room for dimensional found objects to be housed in the middle. Here a Bakelite belt buckle becomes a picture frame within the domed frame of the eyeglass lens.

1

2

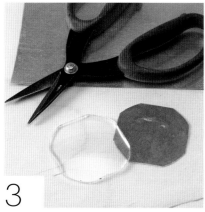

3

4

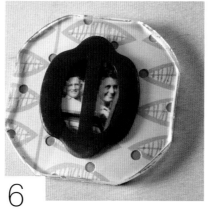

5

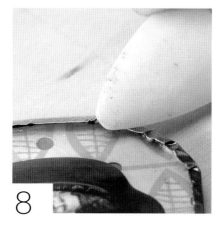

6

7

8

1. The fun of using an eyeglass lens is being creative with what you display beneath the convex shape.

2. For this project I chose a vintage Bakelite buckle as a frame to house my image. Use the belt buckle to select the composition, then glue the buckle on top of the picture, and trim away the excess.

3. Cut the aluminum flashing the same size as the eyeglass lens, making sure that the aluminum flashing does not extend beyond the perimeter of the lens. Use utility or Tonic shears to cut the aluminum flashing.

4. If you want to use the same design as the sample, use the lens as a guide and cut pieces of mat board, card stock and decorative paper to the same size as the lens.

5. If you want to add some sparkle or another layer of texture to your decorative, use a Sakura gel pen in the color Clear Star to highlight the pattern of the paper and give it more texture. To add the holes, use a hole punch; the circles add another layer of design and color.

6. Use craft glue, double-stick tape or a glue stick to assemble all the pieces. If you use craft glue, use it sparingly so it doesn't seep or ruin the piece.

7. Clamp the piece together. Determine the width of the copper foil tape and wrap the piece referencing the instructions for how to wrap copper tape in the *Toggle-Clasp Pendant* project. Remove the clamp and start pinching the tape down on the front and back sides using two fingers.

8. Burnish the edges but be careful when burnishing the outer edge so you don't puncture the copper foil tape along the edge of the aluminum flashing. When working with bevels or domed glass, I find it's easier to place that edge over the edge of a table to burnish.

73

9 When you overlap your ends, sometimes they don't match.

10 If your ends don't match up, use a craft knife and trim off any excess.

11 When you are working with circles, set your rheostat down a little bit so the solder sets more quickly.

12 Tin the back of the piece. See instructions for tinning in the *Toggle-Clasp Pendant* project. If you are working with a piece that is domed or beveled and spinning around, make sure to hold your piece still with the length of solder as you are working.

13 If solder drips over the edge, you don't always have to add more solder but can use what is there, keeping in mind that you have to melt it through while tapping it out. Any mistakes that you see while working will probably be soldered out by the end.

14 If you get steam under your glass, it will dry out. It is the nature of a dimensional piece to generate internal steam during production.

15 If it steams, that's OK—you can use a blow dryer set on "cool" to remove some of the vapor. First, you must let the piece cool off because glass going from extreme heat to cool can shatter or crack. It is the nature of the beast that sometimes you will get more steam in some projects than others. Just burnish the copper as well as you can.

16 Attach the sterling silver jump rings. You can draw a line with a Sharpie at the point where you are going to attach your jump rings; the mark will just polish out. Clamp your piece in the center, pushing the feet of the clamp down so your piece is stabilized. Make sure you put flux on the open end of the jump rings and where you are going

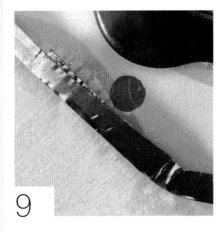
9

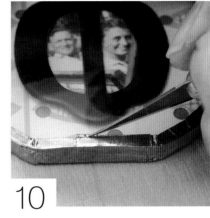
10

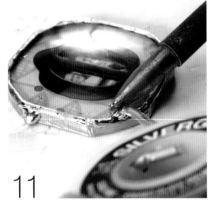
11

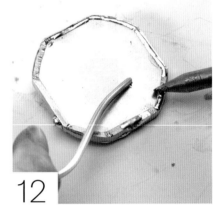
12

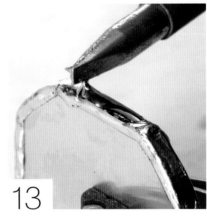
13

14

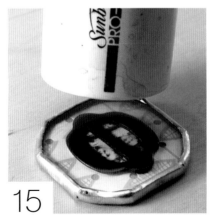
15

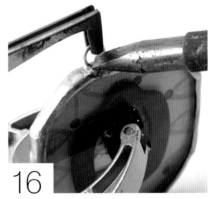
16

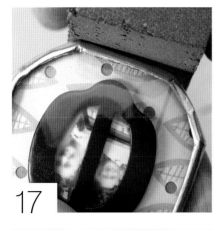

17

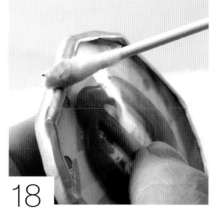

18

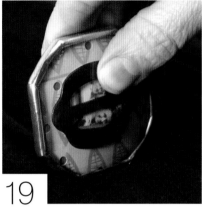

19

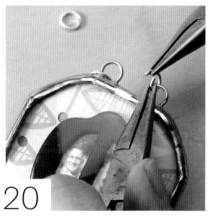

20

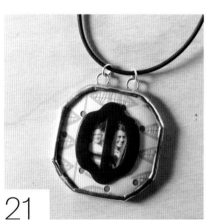

21

to set your jump rings. Get a bead of solder. Hold your first jump ring with your tweezers and, holding it in place, melt the bead of solder into the solder that's already there. Repeat with the second jump ring.

17 The next step is to polish your piece. If the Silvergleem dries cloudy, buff it out with a fine-grit manicure sanding sponge. Don't buff so much that you sand the solder off. Use a light hand and a gentle touch.

18 To get a more brilliant shine on your Silvergleem, use a polishing compound. Tip: put rocks in your bottle to help mix the particles together. You don't want to contaminate the bottle, so put a little polishing compound in another container. Use a cotton swab to apply the polishing compound to the solder. Let it dry just like car wax until it gets cloudy white.

19 Once it is dry, polish it using a soft cloth. To get a better finish, put the cloth on the table and rub the whole piece all over the rag to give a more consistent look.

20 Using needle-nose pliers, add jump rings.

21 Slip a leather cord or ribbon through the jump rings and tie a bow.

NOTE

If you overwork your piece, there is a great chance of getting internal steam buildup.

Materials

- Basic soldering tool kit
- Solder, 60/40
- Copper foil tape, cut to size
- Circle cut pane of glass, to your chosen size
- Printed collage or photograph

- Metal ruler with foam or cork backing
- Ball chain
- Tonic shears
- Wire cutters
- Needle-nose pliers
- 24-gauge copper sheet

- Awl
- Fine-grit manicure sanding sponge
- Mat board
- Rubber gloves
- Jax Pewter Black Patina
- Novacan Black Patina
- Cotton swabs

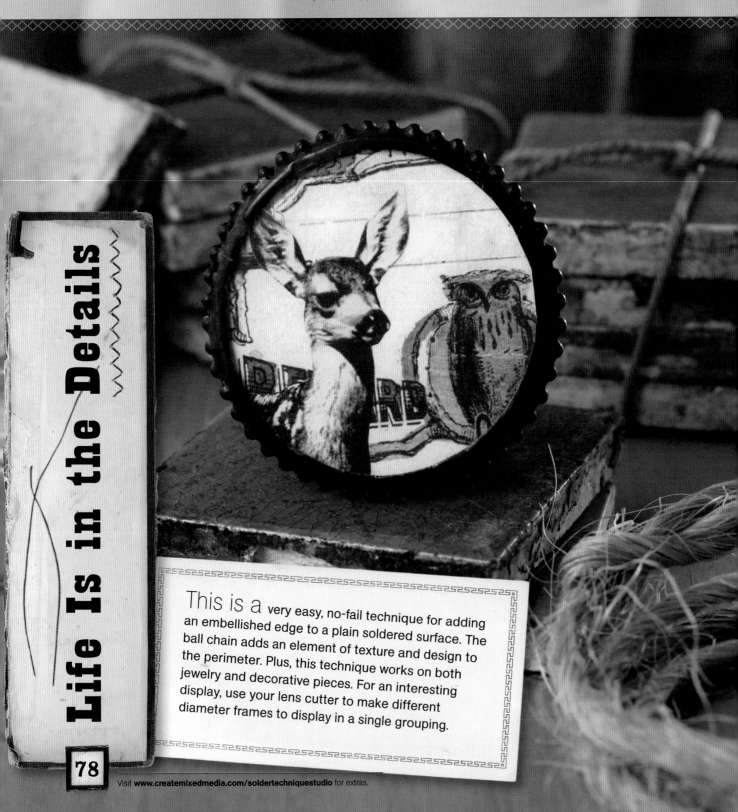

Life Is in the Details

This is a very easy, no-fail technique for adding an embellished edge to a plain soldered surface. The ball chain adds an element of texture and design to the perimeter. Plus, this technique works on both jewelry and decorative pieces. For an interesting display, use your lens cutter to make different diameter frames to display in a single grouping.

Visit **www.createmixedmedia.com/soldertechniquestudio** for extras.

1

2

3

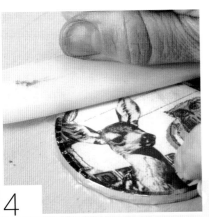

4

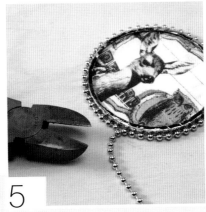

5

1 Reference *Cutting Circles* to cut a circle out of glass. Also cut a piece of mat board that you will use for the back of the frame. It needs to be the same size and shape as the glass. To serve as the visual of your piece you will also need a collage or photograph that is cut down to the same size as the glass.

2 Clean the glass. Sandwich your pieces together from back to front: the mat board, the image and the glass. Secure the pieces together with a clamp. Determine the width of the copper foil tape needed by measuring the perimeter and cut the length off the roll approximately ½" (12mm) longer than the perimeter.

3 Wrap the glass following the steps you saw in the *Toggle Clasp Pendant* project. Once the glass is wrapped in the copper foil tape, use two fingers to start pinching the copper foil tape edges down towards the glass and towards the mat board in the back.

4 Burnish well on all sides, not forgetting to burnish the overlap. Once you finish burnishing your piece, apply flux and tin the copper foil tape. Reference the *Last Minute Recap* for tinning instructions. When using a paper or mat board backing, don't use too much flux; you don't want to get the paper dirty. And be careful not to touch the mat board with the iron.

5 After you tin the whole piece, wrap the ball chain around the perimeter of the circle, and then trim off the excess using wire cutters.

79

6. Add flux around the ball chain on the outer edges and tack solder the chain to the edge of the piece. Reference the *Soldering Surfaces* section for instruction on how to tack solder.

7. Add enough solder that you let the solder seep into the ball chain without covering up the balls. Add the solder from the inner edge of the copper foil tape flowing out towards the ball chain. Like water, liquid solder flows down; you want it to flow down and fill in the gaps. Let it flow down until you achieve your desired look.

8. Keep working around until you fill in the gaps and have the desired effect.

9. If you are making this as a wall hanging, add wire as shown in the *Spelling Bee* project. Add patina to the solder and the ball chain. You may need to use a combination of patinas, Novacan Black for the solder and Jax Pewter Black for the ball chain.

10. The next step is to make the stand. If you already patinaed your piece and you decide that rather than making a wall hanging you want to make a standing photo frame, no problem! Use a fine-grit manicure sanding sponge and sand off the area where you want to attach the stand. Using 24-gauge copper, measure the diameter of the circle using a ruler so you know how wide to cut the bracket. Once you determine that measurement, use a center punch or an awl and score the line along the ruler. Use a pair of metal shears to cut along the score line.

6

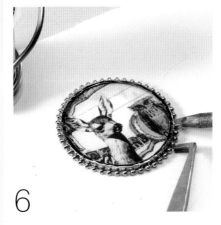

7

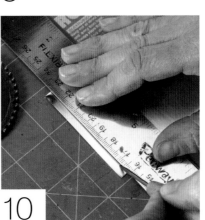

8

9

10

Visit **www.createmixedmedia.com/soldertechniquestudio** for extras.

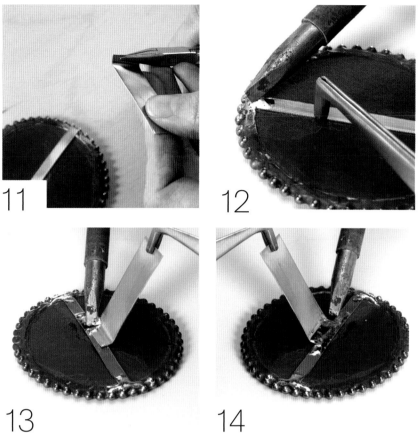

11

12

13

14

11 Find the center and tack solder the bracket in place. If it helps you can mark your center with a Sharpie.

12 To make the leg portion of the stand, determine the length of the stand, add an extra ¼" (6mm), and at the ¼" (6mm) mark use pliers to bend the ¼" (6mm) portion upward to create an angle.

13 Tack solder the stand.

14 As you are tack soldering the stand, make sure to hold the copper with tweezers for stability and because the heat transfers through the copper.

15 Here is the finished frame. For an interesting display, use various size circles and differing diameters of ball chain.

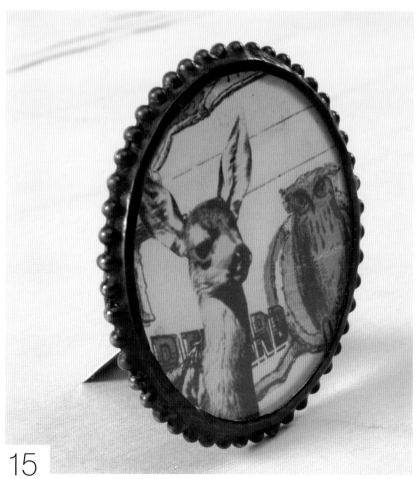

15

81

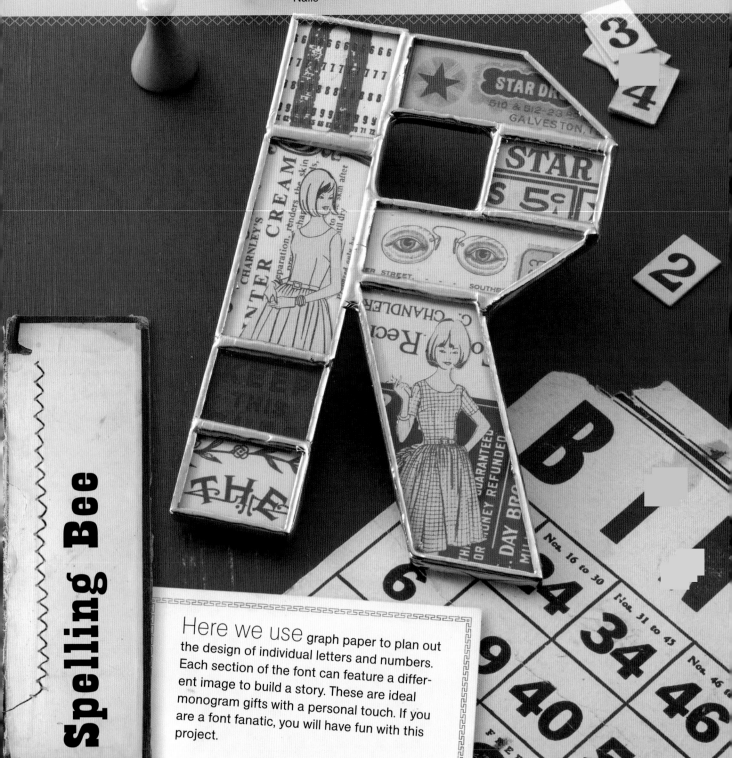

Materials

- Basic soldering tool kit
- Solder, 60/40
- Copper foil tape, cut to size
- Glass, cut to pattern size
- ¼" (6mm) scale grid paper

- Patterned scrapbook paper, images or ephemera
- Pencil
- Ruler
- Foam core
- Nails

- Mat board
- 20-gauge nickel silver wire
- Wire cutters

Spelling Bee

Here we use graph paper to plan out the design of individual letters and numbers. Each section of the font can feature a different image to build a story. These are ideal monogram gifts with a personal touch. If you are a font fanatic, you will have fun with this project.

1

2

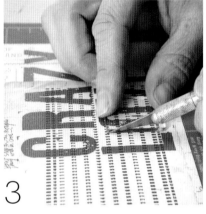

5

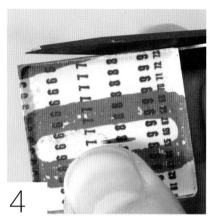

3

4

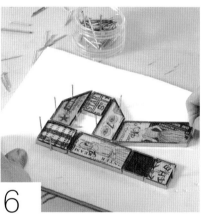

5

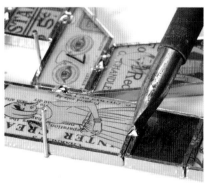

6

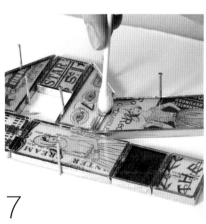

7

8

1. Using the grid paper, sketch out your letter or number. Number each section. Cut out a piece of glass and mat board to correspond with each section. Reference the *Cutting Straight Lines* section for how to cut glass.

2. Number the glass pieces to correspond with each section on the grid paper. This will be your image guide. See template in the back of the book.

3. Using scissors or a craft knife, cut out your images. Reference the *Toggle-Clasp Pendant* project for how to trim your image.

4. Once you have it all cut out, hold each image up to the glass and trim off any excess beyond the boundaries of the glass. Clean the glass. Sandwich the image between the glass and mat board, and wrap with copper foil tape. Reference the *Toggle-Clasp Pendant* project for how to wrap glass. One important thing when wrapping glass pieces that are going to be tack soldered together is that you want all your overlapping seams facing the inside edges. You don't want the overlapping seams on the outer edges of the piece.

5. Place each wrapped section on the corresponding number on top of the grid paper sketch.

6. Think of this as a puzzle and place it on the foam core. Use nails to pin them in place. The idea is that you want to secure it in as many places as you can so when you go to tack it together, your pieces don't move around.

7. Apply flux to each inside section that is touching another inside section.

8. Apply a bead of solder on each area where you applied flux. Think of tack soldering as gluing the pieces together so you can move it around without the pieces coming apart.

Sign up for the free newsletter at **www.createmixedmedia.com**.

83

9 Apply flux to the front of your piece and tin the front perimeter.

10 Turn the piece over and apply flux to the back outer perimeter and inside seams, and then tin. Use just a quick layer of solder over the copper. No need to worry about building a bead on the back.

11 Turn the piece over and start to build up the inside seams.

12 Once you have built up a nice bead on the interior seams, work on building a bead around the outer edges. Remember when you are soldering the edge to use the solder that is already there; you don't always have to add more solder. And remember to use a tapping motion; don't use your iron like a paintbrush. Always keep your piece parallel to the work surface.

13 Determine where you want to add your hanger. Mark it with a Sharpie. Cut wire down to size. Tack solder the piece of wire on one end. Remember, hold it still till the solder cools, or else you will just pull it.

14 Repeat on the other side.

15 Clean and buff out the solder or add a patina.

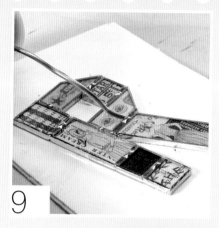
9

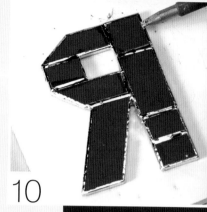
10

11

12

13

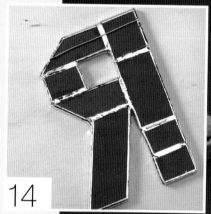
14

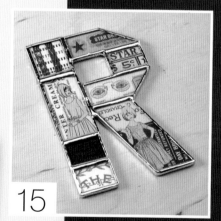
15

TIP

If soldering for a baby's name, use lead-free solder. But if this is something that you are going to hang on the wall and no one is going to touch it, you can use leaded solder.

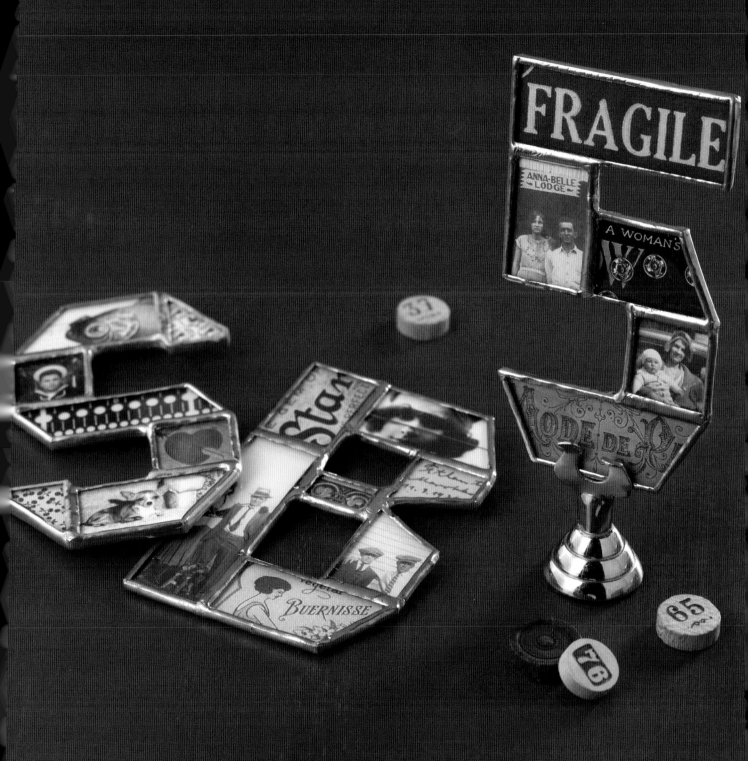

Materials

- Basic soldering tool kit
- Solder, Silvergleem
- Copper foil tape, cut to size
- Glass, cut to size (Note: add 1/32" [1mm] to the bottom edge measurement of the roofline glass. Sizes: 1½" × 1" [38mm × 25mm], 1½" × ½" 38mm × 12mm]. Roof: height 1" × bottom length 1 17/32" [25mm × 39mm]. Find the center and cut your angle for center top mark to corner.)
- Patterned scrapbook paper, images or ephemera
- Chain-nose pliers
- Foam core
- Nails
- 2 sterling silver jump rings
- Chain
- 19-gauge annealed wire for clasp (hook and ring)
- Double-barrel pliers
- Rubber gloves
- Jax Pewter Black Patina
- Cotton swabs

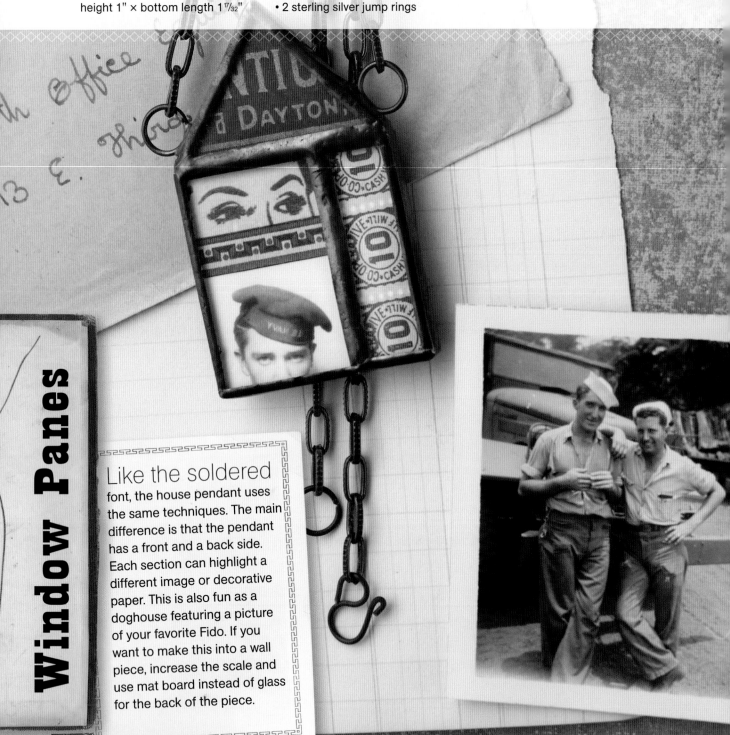

Window Panes

Like the soldered

font, the house pendant uses the same techniques. The main difference is that the pendant has a front and a back side. Each section can highlight a different image or decorative paper. This is also fun as a doghouse featuring a picture of your favorite Fido. If you want to make this into a wall piece, increase the scale and use mat board instead of glass for the back of the piece.

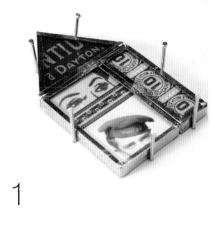

1

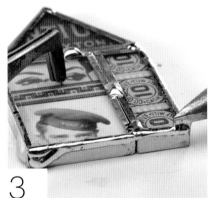

2

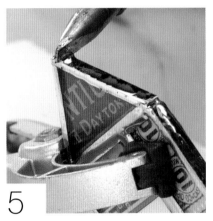

3

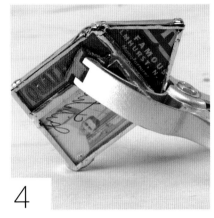

4

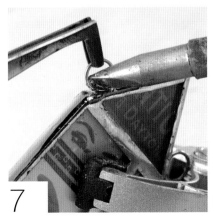

5

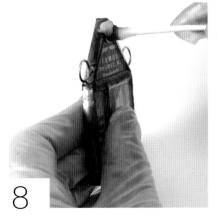

6

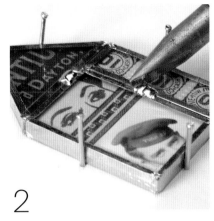

7

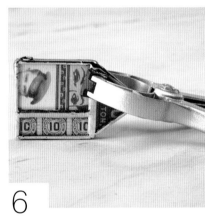

8

1. See sizes in the Materials list for the six pieces of glass cut down to size and six images cut down to size. Place the pieces on top of the foam core and arrange the pieces to fit together like a puzzle. Use nails to keep the pieces from moving when tack soldering.

2. Apply flux to the seams on the glass and tack solder.

3. Tin the outer perimeter of the front; turn the piece over and tin the outer perimeter of the back. Once you have tinned the front and back, apply flux to the seam and build the bead on the interior seams of the house. Repeat on the back inner seams.

4. Using a clamp, brace the angled roof of the house so it sits parallel to the table.

5. Working on the roofline, add a bead of solder and tap out your bead.

6. Work your way around the perimeter of the glass, building up your bead.

7. Again, brace your piece so the roofline is parallel to the table and add your jump ring. Repeat on the other side.

8. Clean the solder, then patina.

87

Sign up for the free newsletter at **www.createmixedmedia.com**.

9 Make a clasp using your preferred technique or use a manufactured clasp.

10 Assemble the chain and add it to the house pendant.

9

10

NOTE

I used Silvergleem because this is a pendant, or you can use lead-free solder and Jax Pewter Black to patina.

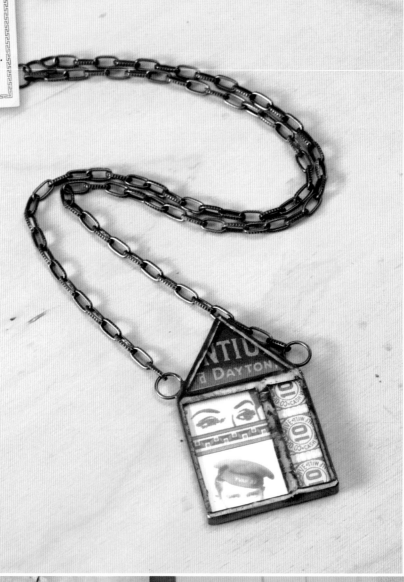

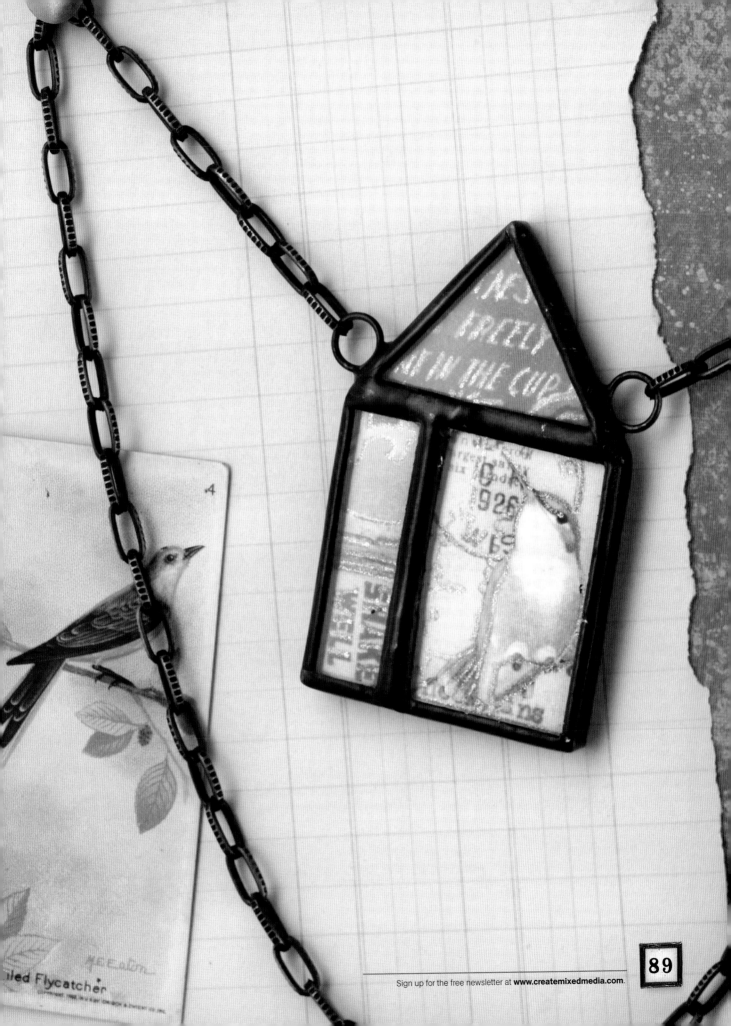

Materials

- Basic soldering tool kit
- Lead-free solder
- Black-backed copper foil tape, cut to size
- Black-backed copper foil tape sheet, for star or decorative shape
- Pane of glass for front cover, size 2½" × 2" (64mm × 51mm)
- 24 pieces of paper for signatures, size 1⅞" × 4⅞" (48mm x 124mm)
- 6 decorative papers for outside each signature, size 1⅞" × 4⅞" (48mm × 124mm)
- Mat board for back cover, size 2½" × 2" (64mm × 51mm)
- Patterned paper for back cover, size 3" × 2½" (76mm × 64mm)
- Metal ruler with cork backing
- Fine-tip Sharpie
- Flex shaft drill with foot pedal and ⅛" (3mm) hollow core diamond drill bit
- Safety glasses
- Water
- Plastic bowl/container
- Wooden block smaller than the plastic container
- ⅛" (3mm) hole punch
- Awl
- Hammer
- Glue stick
- Star punch or decorative punch
- 2 needles
- Black waxed linen bookbinding thread
- Binder clip
- Scrap piece of paper
- Rubber gloves
- Jax Pewter Black Patina
- Cotton swabs
- 7gypsies rub-ons, optional

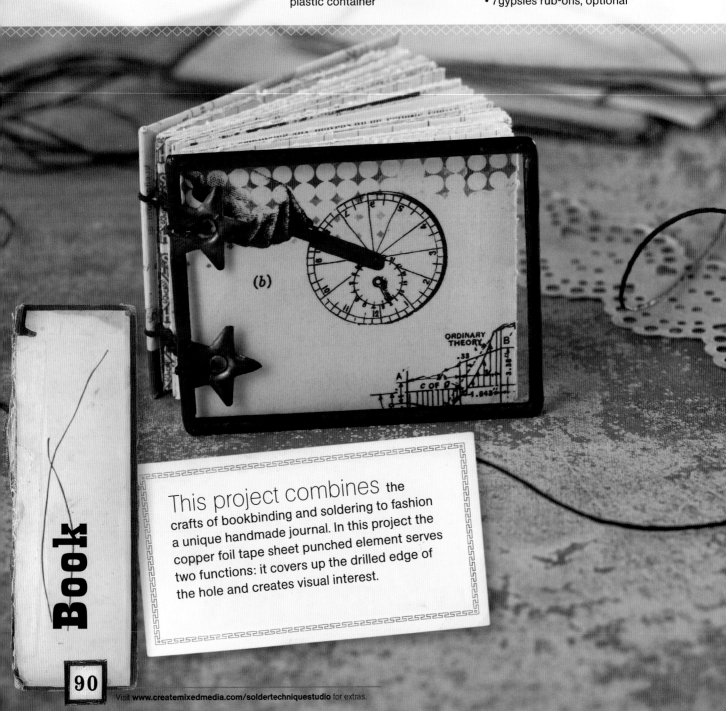

This project combines the crafts of bookbinding and soldering to fashion a unique handmade journal. In this project the copper foil tape sheet punched element serves two functions: it covers up the drilled edge of the hole and creates visual interest.

Book

Visit www.createmixedmedia.com/soldertechniquestudio for extras.

1

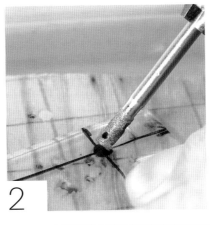

3

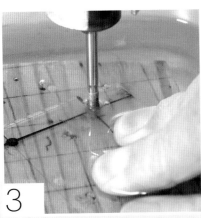

1

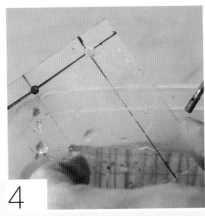

4

1 Using a fine-tip Sharpie and a cork-backed ruler, mark your glass ¼" (6mm) in from the spine and ½" (12mm) in from the top and bottom edges. We will drill a hole at the intersection of these lines in order to bind the book. Using your Sharpie, make a circle approximately ⅛" (3mm) in diameter over the intersection. This marks where you will drill the holes.

2 Using a flex shaft drill and a hollow core ⅛" (3mm) drill bit, prepare to drill out your ⅛" (3mm) circles. To begin, get a shallow plastic bowl/container that is large enough in diameter to fully contain your glass, and a piece of wood smaller than the bowl that fits within the diameter of the bowl when your glass is placed on top of the piece of wood. Place the wood in the bowl and place the glass on top. Fill the bowl with enough water that when you place your glass on top of the wood, the water hovers just above the glass. If you add too much water, it will distort your view. The next steps require a flex shaft drill with a foot pedal. It mimics the foot pedal function of a sewing machine. Do this wearing safely glasses and a mask. Holding the drill at a 60-degree angle to the glass, gently push on the pedal, starting in a slow motion to begin a pilot hole notch.

3 Hold the drill extremely steady and maintain a slow foot pedal speed, and slowly move the drill to a vertical position. Once the drill is vertical, accelerate to a medium speed to finish drilling out your circle. Do not push on the drill; allow it to do the work for you. You will feel the give into the wooden block once you fully pierce the glass. Keep the drill moving and pull straight up and out to remove the bit.

4 Repeat step 3 to drill the other hole. More often than not, you are going to splinter the glass around the hole. It doesn't matter too much because you will be covering up the holes with copper sheeting.

TIP

The drill bit will get little bits of glass in the hollowed out part. Use little pieces of wire to clean it out.

91

Sign up for the free newsletter at **www.createmixedmedia.com**.

5

6

7

8

5 The next step is to make the signatures, the equal-sized bundles of paper that will be folded in half. The paper should be ¹⁄₁₆" (2mm) smaller on the top and bottom than your overall glass, and ⅛" (3mm) shorter from the outer front edge. When the piece is folded into a signature, it should fit within the perimeter of the book covers. In this project, we use decorative paper on the outside of each signature and fill the inside with four sheets of ledger paper. Next, take the flat sheet of decorative paper and fold it in half; repeat this process with the four sheets of ledger paper until you have a stack of five folded sheets, making ten pages. Repeat this five more times until your book has six signatures totaling sixty pages.

6 Using a scrap piece of paper, make a template the same size as one of your signatures. Place the folded sheet above the holes on the back of the book and mark the hole location on the fold. Take that sheet, unfold it and reverse the fold so the holes are on the inside of the fold.

7 Open a phone book or a large book at the halfway point, and place a signature in the opened book with your template on the inside of the signature. Using an awl, pierce through the holes in your template through all the pages of the signature. Repeat this for each signature.

8 The back of the book is made of a piece of mat board or book board. Make the book board the same size as the glass. Using the glass as your template, mark the holes and use a ⅛" (3mm) hole punch to create holes for the back. Measure a piece of decorative paper ½" (12mm) larger than the outer perimeter of the book board. This will become the back cover; we will create tidy mitered corners for a finished effect. Using a glue stick, cover the book board with glue until it is tacky and place it on the center of the paper. Using a piece of scrap mat board, place it at an angle across the corner of the board and mark the distance with a pencil. Use that line to cut off the corner. Repeat on the other three corners.

9

10

11

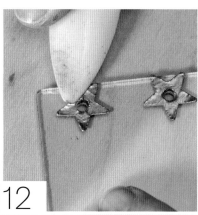

12

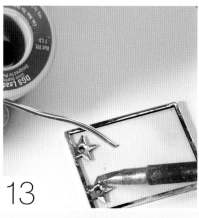

13

14

15

9 Once the corners have been cut off, use a glue stick to apply glue to the tabs that extend beyond the mat board. Fold the tabs onto the book board and press so the glue adheres. Repeat with the three remaining tabs. Your holes are now covered with decorative paper. Feel for the hole depressions, and using an awl, puncture through the paper. Cut another piece of decorative paper ⅛" (3mm) smaller than the perimeter of the back cover. Apply glue stick and center the decorative paper within the tabs. Again, pierce through the covered holes with an awl.

10 From a piece of flat black-backed copper sheet, punch out two star shapes larger in diameter than your drilled holes. These will serve as frames for your holes and extend to the edge of the glass. You can create any shape you want; the goal is to cover the splintered edge of the drilled hole.

11 Use a ⅛" (3mm) hole punch to punch out a hole in the center of the star.

12 Clean your glass. Remove the backing from the stars and stick them in position. For steps 13, 14 and 15, reference the *Toggle-Clasp Pendant* project. For this project I use lead-free solder and since I am using lead-free solder, I am using Jax Pewter Black Patina for an antiqued finish.

16 Add more dimension to the cover using a rub-on design.

17 We now have a binder clip, six signatures, a glass cover, the back cover and a piece of linen thread with needles on each end. To determine the length of the thread, measure the length of the spine for each signature and add three extra lengths to create one long piece of thread. Make sure all the signatures are facing right-side up. Organize the signatures in the order in which you want them to appear in the book.

18 Pick up the last signature of the book. Take the needles and insert them on the center fold of the signature and pull the thread evenly through each hole. Allow it to have a bit of play so it is not tightly affixed to the inside fold.

19 Run those needles through the holes in the back cover. As shown in the image, this is easier to manage if you prop the back cover against the edge of a table or a block of wood. Thread the needles through the corresponding holes in the back cover.

20 Take the needle up and over the back cover spine and into the corresponding hole in the first signature. Repeat on the other side.

21 Crisscross the needles on the inside and come out the opposite hole in preparation for adding the next signature.

22 Place an open signature and clamp it into position. Use a piece of scrap paper against the clamp so as not to mar your signatures.

23 Pull the needles through the corresponding holes and crisscross them inside the signature and come out the opposite holes.

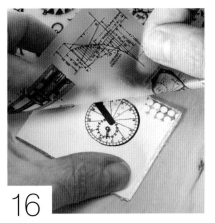
16

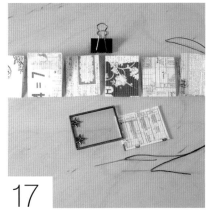
17

18

19

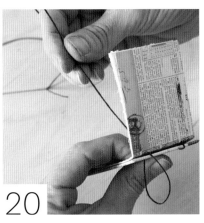
20

21

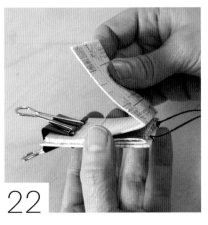
22

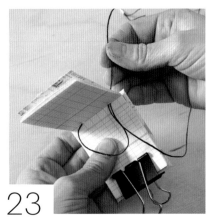
23

Visit **www.createmixedmedia.com/soldertechniquestudio** for extras.

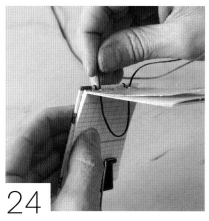

24

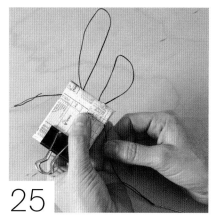

25

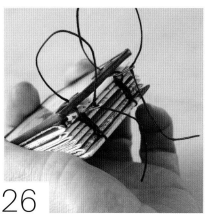

26

27

24 The next step is to make an exposed chain stitch, which is both functional and decorative. This is called a *kettle stitch*. Take the needles and retighten the thread while allowing for a bit of give between each signature. If the thread is pulled too tight, your book will not lie flat easily and will tend to pop open. Take the needles down on the inside of the stitch and place the tip of the needle in between the first signature and the back cover.

25 With the tip of the needle in place, come out the end of the book, tighten around the existing stitch between the first signature and the book cover, and pull up on the thread to create a loop chain stitch. Repeat on the other side. Tighten the thread to create a loop, clamp on your third signature, pull the needles up and place them into the corresponding holes. This will secure the next signature into position. Repeat steps 23–24 and make a kettle stitch just below the signature you just added. Repeat until all signatures have been added.

26 Once you've added your last signature, place the cover on top of the book, then take the threads under the hole in the cover of the book and out through the top. Bring the thread down over the spine edge and make a kettle stitch below the last signature, then make your loop and bring the needle back through the same hole. Repeat on the other side.

27 Bring the needles into the book through the corresponding holes and tie into a square knot. Trim off the excess.

BOOK ANATOMY

→ The top of a book is called the *head*.
→ The bottom of a book is called the *tail*.
→ The center between the back and front covers is called the *spine*.
→ The stack of paper that makes up the pages is called a *signature*.
→ The holes in a signature are called *stations*. (I called them holes in the step outs.)
→ The piece of paper that covers the inside of the back cover is called an *end paper*.

Materials

- Basic soldering tool kit
- Solder, 60/40
- Copper foil tape, cut to size of the heart
- Black-backed copper foil tape flat sheet, cut to size
- ½" (12mm) black-backed copper foil tape, cut to size (bottom of the heart)
- ½" (12mm) black-backed copper foil tape, cut to size (neck of the bottle)
- Glass, cut to size
- Images
- PanPastels and applicator
- Lathekin
- Sharpie
- Vintage bottle
- Tonic shears
- Leather and rubber gloves
- Novacan Black Patina
- Cotton swabs

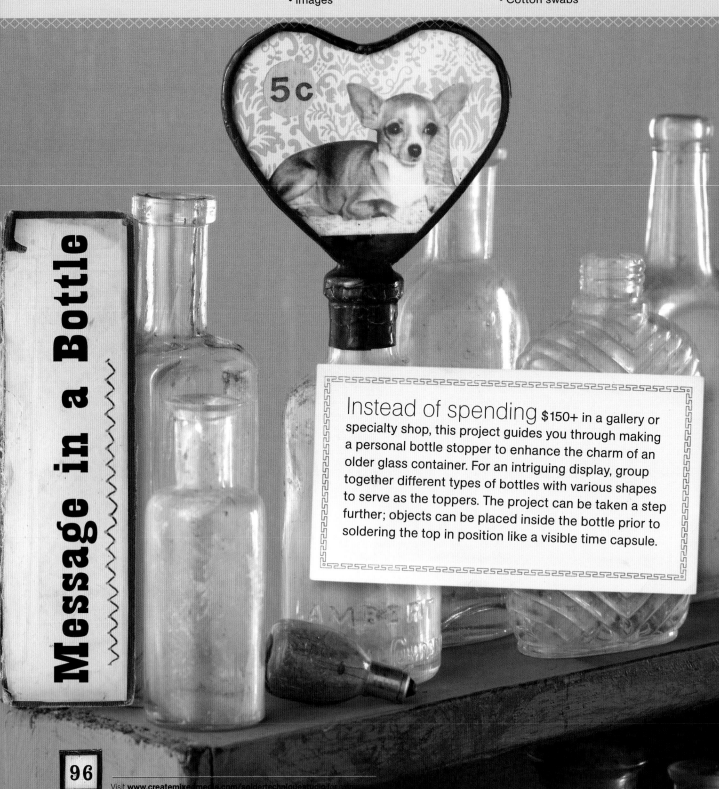

5c

Message in a Bottle

Instead of spending $150+ in a gallery or specialty shop, this project guides you through making a personal bottle stopper to enhance the charm of an older glass container. For an intriguing display, group together different types of bottles with various shapes to serve as the toppers. The project can be taken a step further; objects can be placed inside the bottle prior to soldering the top in position like a visible time capsule.

Visit **www.createmixedmedia.com/soldertechniquestudio** for more

1

2

3

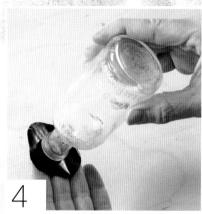

4

1 Cut out two heart shapes from a sheet of glass. See *Cutting Shapes: Heart* for instructions. You will need two collages, one for the front and one for the back. To add color to black-and-white photocopies, I like to use chalks like PanPastels. Using the glass heart as a template, cut out your two collages. If cutting shapes from glass is too daunting, use a rectangle or square.

2 Clamp all the pieces together so your collage shows through on each side. Notice that the bottom pointy tip of the heart has been cut off to provide a stable flat surface. Affix a piece of copper foil tape along the bottom edge of the heart. Tuck the pieces towards the opposite side, turn the heart over and affix a ½" (12mm) piece of copper foil tape on the opposite side. If any corners stick up along the top edge of the copper foil tape, use a craft knife to trim them off.

3 Determine the length of the copper foil tape needed by measuring the perimeter and adding an extra ½" (12mm) for overlap. Cut the length off. Starting at the bottom, wrap the piece of glass. See the *Toggle-Clasp pendant* project for instructions. Run a lathekin back and forth along the copper tape in the deepest part of the curve at the top of the heart. This stretches out the copper foil tape to fit within the curve. As you repeat this motion, push the tape down towards the glass. The tape may tear a bit; if it does that's OK—it's handmade and that lends authenticity.

4 Using a flat sheet of black-backed copper foil tape, cut out a circle that when placed on the top of the bottle, has enough depth to extend and sit below the neck of the bottle. Peel off the backing from the circle and set the open neck of the bottle in the center of the circle.

5 With scissors notch the outer edge of the circle to create notched tabs with scissors. One by one, bend the tabs over and down below the lip of the bottle. Repeat this until all the tabs are smoothed down on top of each other.

6 Using a bone folder, burnish the copper foil tape. Don't forget to burnish below the lip.

7 Cut a length of ½" (12mm) black-backed copper foil tape that will wrap around the neck of the bottle just below the lip. Make sure you have enough to overlap the end.

8 Burnish all the copper foil tape.

9 Apply flux to the top of the bottle, then tin the top. Set that aside and solder the heart. See soldering instructions in the *Toggle-Clasp Pendant* project.

10 Mark a center line across the top of the bottle with a Sharpie. This is where you will attach the topper. Apply flux.

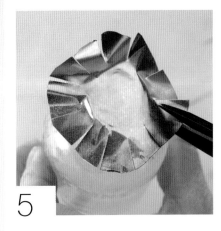

5

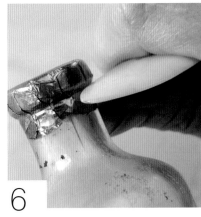

6

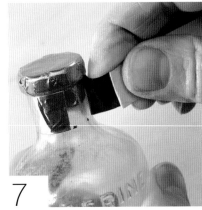

7

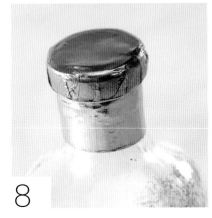

8

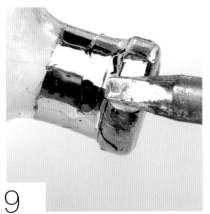

9

10

11

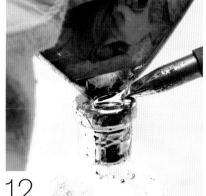

12

13

14

15

16

11 Apply flux to the bottom of the heart. Wear a glove on the hand that will be holding the heart. Place the heart on the line, and straighten it out.

12 Pick up a bead of solder with your iron and melt it into the seam between the bottom of the topper and the bottle.

13 Apply flux and add more solder on the other side and on the outer edges until all the gaps are filled in. Remember, a little solder goes a long way! Clean the solder and remove flux residue.

14 Patina the solder.

15 To get a gunmetal finish on the patina, use a rag with a bit of metal polish and rub it over the patina until you achieve a desired color. Be careful not to overrub the patina—it's possible to remove too much.

16 Clean your piece a final time.

TIP

To give patina luster, buff out with polishing compound.

Sign up for the free newsletter at www.createmixedmedia.com.

99

Materials

- Basic soldering tool kit
- Solder, 60/40
- Copper foil tape, cut to size

- Glass, cut to pattern size
- Patterned scrapbook paper, images or ephemera
- Weights or boxes

- Jump ring
- Leather and rubber gloves
- Novacan Black Patina
- Cotton swabs

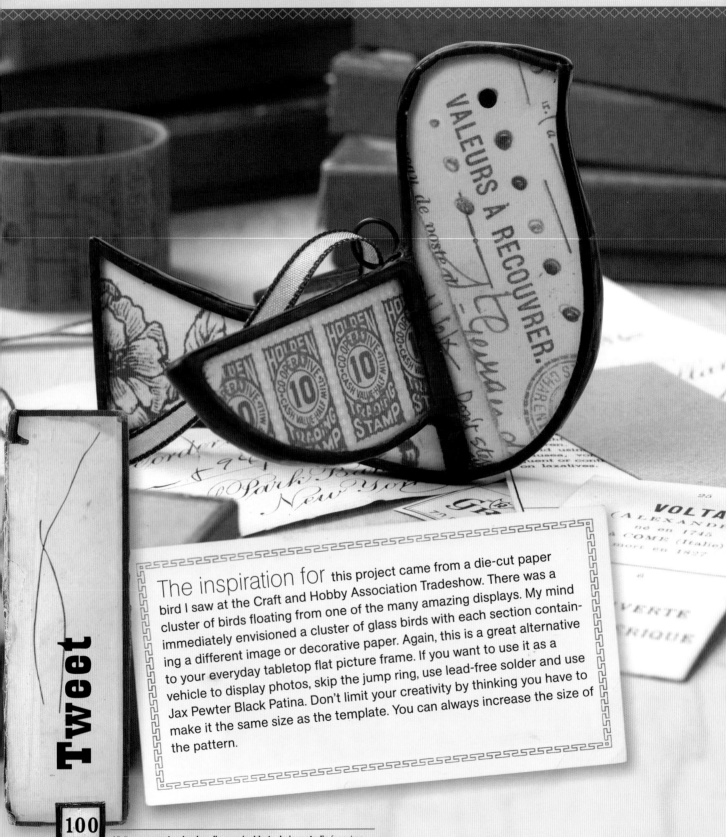

Tweet

The inspiration for this project came from a die-cut paper bird I saw at the Craft and Hobby Association Tradeshow. There was a cluster of birds floating from one of the many amazing displays. My mind immediately envisioned a cluster of glass birds with each section containing a different image or decorative paper. Again, this is a great alternative to your everyday tabletop flat picture frame. If you want to use it as a vehicle to display photos, skip the jump ring, use lead-free solder and use Jax Pewter Black Patina. Don't limit your creativity by thinking you have to make it the same size as the template. You can always increase the size of the pattern.

Visit **www.createmixedmedia.com/soldertechniquestudio** for extras.

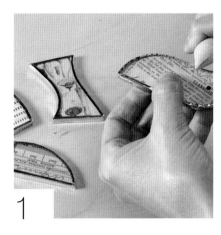

1

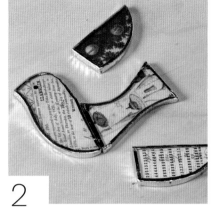

2

3

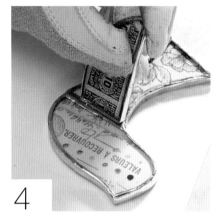

4

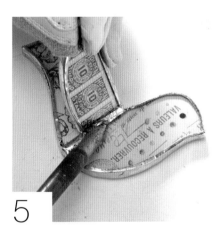

3

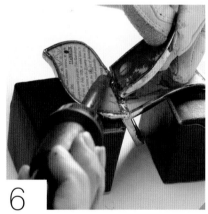

4

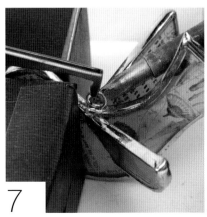

5

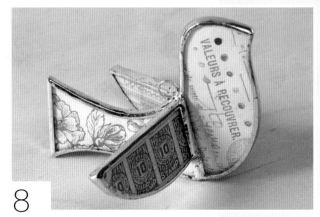

6

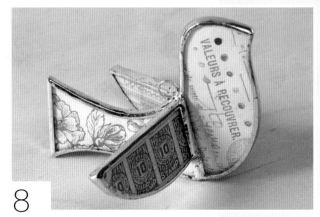

7

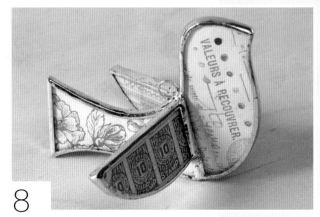

8

1 Using the pattern in the back of the book, trace the pieces on your glass. See *Cutting Shapes: Bird* for instructions and cut out the bird. You will need eight corresponding collages or decorative papers. Wrap the pieces. See the copper foil wrapping instructions in the *Toggle-Clasp Pendant* project for help. When going around the deep curves, use the lathekin to smooth the copper foil tape down towards the glass in such a manner as to not tear the tape.

2 Piece together the body of the bird. Tin all your pieces.

3 Add a spot of flux at the seam and tack solder.

4 Wearing a leather glove on the hand that will hold the wing, place the wing on the seam in the middle of the bird and hold at an angle. Apply flux.

5 Add beads of solder and build up the bead.

6 Using two weights or boxes, balance the bird as shown. Attach the other wing. Once the other wing is attached, build your bead around the outer edges of the bird and fill in any gaps with solder.

7 Use weights or boxes to brace the bird in a standing position and attach the jump ring. If you need help attaching a jump ring, reference the *Toggle-Clasp Pendant* project.

8 Clean and patina.

Sign up for the free newsletter at **www.createmixedmedia.com**.

Visit **www.createmixedmedia.com/soldertechniquestudio** for extras.

Materials

- Basic soldering tool kit
- Solder, 60/40
- Copper foil tape, cut to size
- 5 pieces of ⅜" (10mm) copper foil tape for pencils, cut to size
- Glass, 6 pieces cut to size
- Aluminum flashing, 6 pieces cut to size
- Images, 6
- Patterned scrapbook paper, images or ephemera
- 5 sharpened #2 pencils, cut to size
- Grid paper
- Weights
- StazOn ink, Jet Black
- Rubber stamp
- Jeweler's saw or hacksaw
- Rubber gloves
- Novacan Black Patina
- Cotton swabs

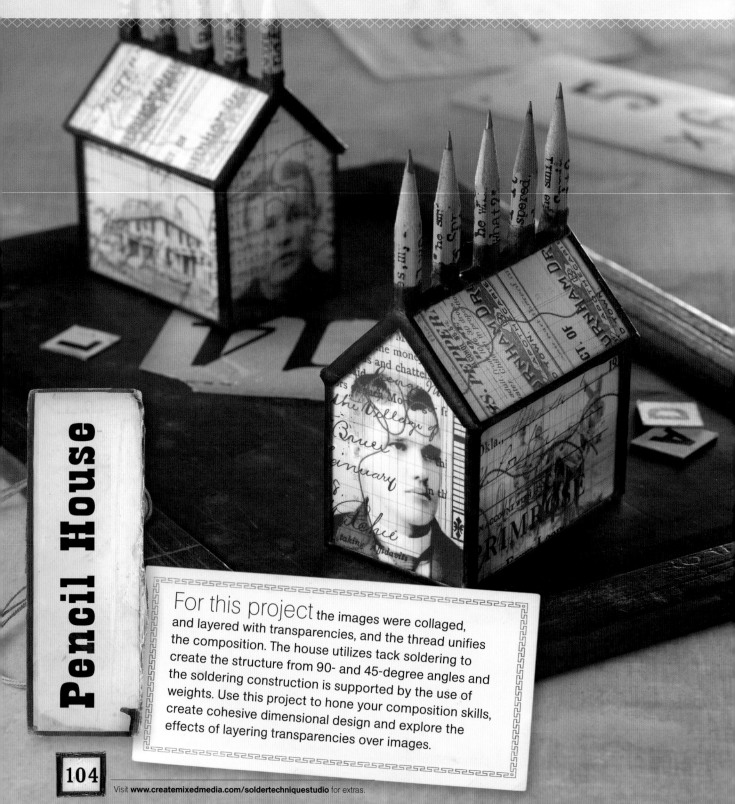

Pencil House

For this project the images were collaged, and layered with transparencies, and the thread unifies the composition. The house utilizes tack soldering to create the structure from 90- and 45-degree angles and the soldering construction is supported by the use of weights. Use this project to hone your composition skills, create cohesive dimensional design and explore the effects of layering transparencies over images.

1

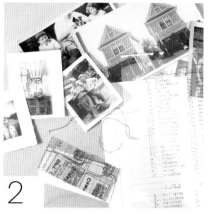

2

3

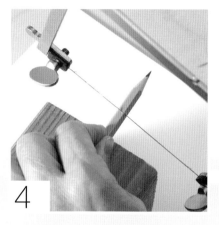

4

5

1 To cut the front and back part of the house with the roofline, you need to determine the overall height of your house, the width of the front and back, and how big the body (the square below the triangle) needs to be. For this project the overall dimensions for the peaked front and back of the house are 2" × 3" (5cm × 8cm) and the body of the house is 2½" (6cm) up the side. To make the roofline, find the top center and cut at an angle on both sides.

2 You can use a variety of ephemera, vintage photos, decorative paper or wallpaper to use behind the glass.

3 Cut out two pieces for the front and back peaked rooflines, two sides and two flat rectangular roof pieces. The sides of the house should be the same height as the body of the front and back. The roof should extend just over the edges of the front and the back and hang over the sides by a fraction. You also need to cut out matching aluminum flashing for each glass piece and make an image for each section. Clean the glass and layer the pieces and wrap with copper foil tape (see how to wrap with copper foil tape in the *Toggle-Clasp Pendant* project). Remember to burnish after wrapping.

4 To make the pencils for the top of the house, sharpen then distress a pencil using sandpaper. Distress to your liking. Determine the length that you would like your pencil to be, then using a hacksaw or jeweler's saw, cut the desired length.

5 Now we are going to stamp words on the pencil. Using an inked rubber stamp with text, lay the inked rubber stamp flat on the table and roll the pencil over it like a rolling pin. Remember to buy the re-inker for the inkpad; because it is permanent ink, it tends to dry out quicker. If you have a bigger stamp, start 1" (25mm) into the stamp and roll off of the edge.

6 Wrap the base of the pencil using ⅜" (10mm) copper foil tape. Place the pencil two-thirds up from the outer edge of the copper foil tape so one-third of the copper foil tape is exposed.

7 Overlap and trim off excess.

8 Push that one-third edge down flat onto the pencil and burnish. Repeat steps 4–7 and make four more pencils.

9 Brace your house in an upright position before starting to solder. I made my own weights using small gift boxes, sand and tape. Work on grid paper to make sure it is all even and squared off.

10 Once your pieces are squared off and aligned, take a small tab of copper foil tape and tape the pieces in place.

11 Apply flux and tack solder each side of the house, repeating steps 9 and 10.

12 Once all the sides of the house are tack soldered, the structure is complete and stable. Don't forget to tin the bottom edge.

13 Tape the roof and tack solder it into position.

6

7

8

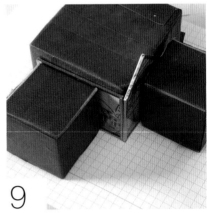
9

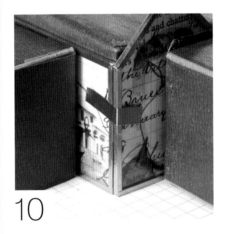
10

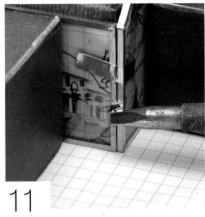
11

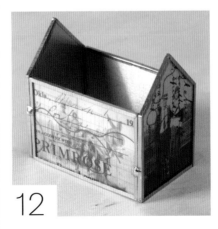
12

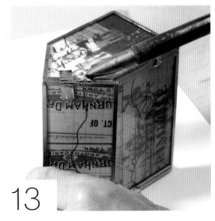
13

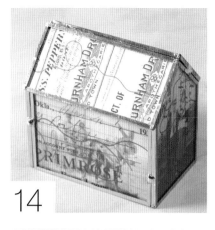

14

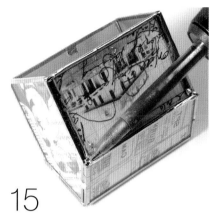

15

16

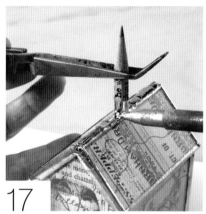

17

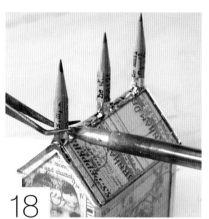

18

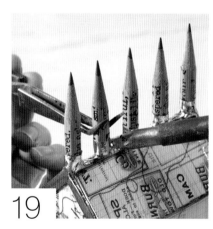

19

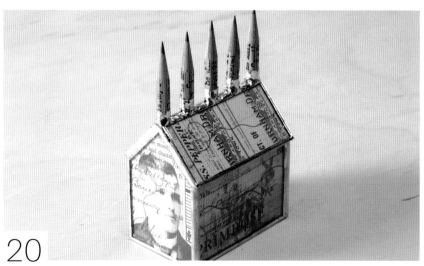

20

14 Repeat step 13 on the other side.

15 Now you are going to tin and build up your beads on the exposed copper foil tape of the house.

16 Apply flux to the copper foil tape on the pencils and tin.

17 Once you tin the pencils, solder the pencils to the house by starting with the pencil in the center. Using tweezers, hold the pencil vertically so it is perpendicular to the roofline. Solder all the way around the pencil.

18 Once the center pencil is soldered into position, add the pencils to the front and back of the house. You now have three pencils in position.

19 Solder the two remaining pencils at the midpoints. Once the pencils are affixed, fill in any gaps along the roofline.

20 Go around with solder and fill in any gaps between the pencils and around the pencils. If the pencils fall out, glue them into place; if they break, take them out and replace. To finish the piece, clean off the flux, patina and clean the glass.

Materials

- Basic soldering tool kit
- Solder, 60/40
- ½" (12mm) black-backed copper foil tape, cut to size
- Copper foil tape, cut to the box size
- ½" (12mm) black-backed copper foil tape to affix the glass
- 32-gauge copper sheet
- Glass pane, fitting on top of your assembled collage
- Acrylic paint, 1 bright color and brown for staining

- Dried tea bags, without tea, flattened and ironed
- Gel medium
- Scissors
- Cuttlebug
- Provo Craft die-cut plate, alphabet typewriter font "Redtag Sale"
- Clear contact paper
- Glass etching solution (Armour Etch)
- Glue
- Weights
- Grid paper

- Assemblage/3-D collage
- Foam core
- Clear tape
- Balsa wood
- Sewing machine
- Threads, red and blue
- Rubber gloves
- Novacan Black Patina
- Cotton swabs
- Jeweler's saw or hacksaw

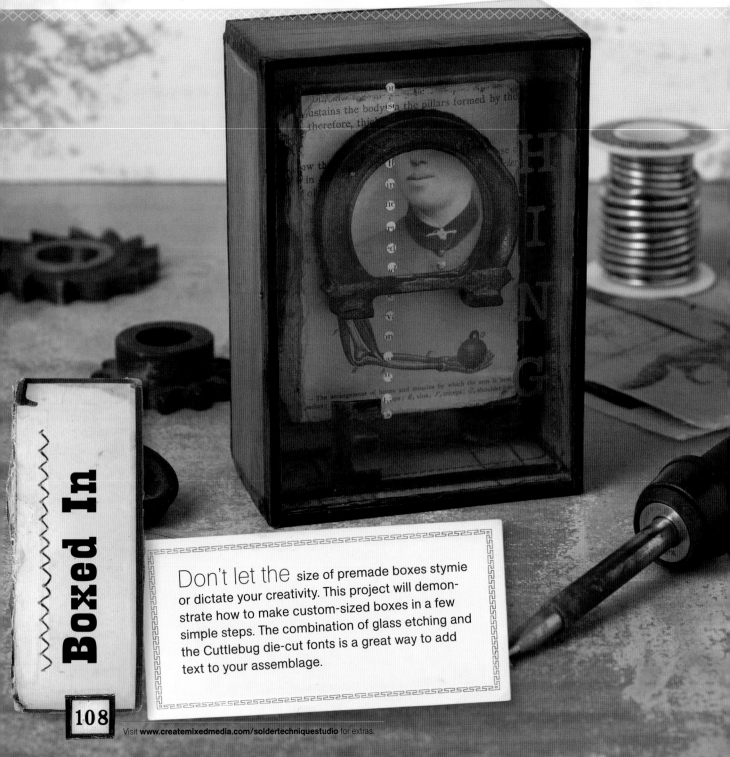

Boxed In

Don't let the size of premade boxes stymie or dictate your creativity. This project will demonstrate how to make custom-sized boxes in a few simple steps. The combination of glass etching and the Cuttlebug die-cut fonts is a great way to add text to your assemblage.

Visit **www.createmixedmedia.com/soldertechniquestudio** for extras.

1

2

3

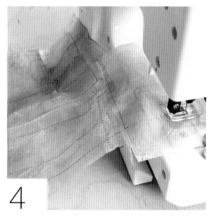

4

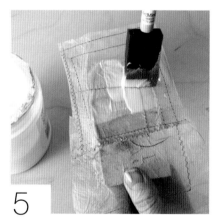

5

1 This project will feature one key word. This example uses the word *hinge*. As shown, the last letter of the word will be copper. The rest will be etched on top of the glass using the contact paper stencils. Cut out the final letter of your word using 32-gauge copper and a Cuttlebug and die-cut.

2 Run the die-cut with the copper sheet through the Cuttlebug machine a couple of times to ensure a crisp, good cut to the letter.

3 Follow the manufacturer's instructions on how to use a Cuttlebug. If you don't have access to a Cuttlebug, you can use other letters to enhance your collage. You will also use the Cuttlebug to cut out the patterns for your stenciled letters. For added interest, I used two different font styles.

4 To embellish the inside of the box, I chose to use stained tea bags ironed flat. See the *Tea bag Plaque* project for instructions. Sew the tea bags together and randomly stitch on them using red and blue threads to create a doodle-like pattern.

5 Determine the size of your box. Use a jeweler's saw or a hacksaw to cut the balsa wood for the top, bottom, back and sides of the box. Paint one side of the balsa wood and stain to your color of choice. On the unpainted side of the balsa wood, apply a thin layer of gel medium. Place the sewn tea bags on top of the gel medium, affix to the balsa wood and apply another layer of gel medium. Repeat with the remaining pieces of balsa wood. Once the gel medium is dry, trim away the tea bag material that extends over the perimeter of the wood. Use the edge of the wood as your cutting guide.

TIP

For added text you can stamp the outside of the box. If you choose to do so, make sure you use StazOn permanent ink and that the paint is dry.

109

6 The next step is to prepare the inside bottom of the box so we can later solder a letter into position. Put a piece of copper foil tape towards the front edge of the bottom, wrap the pieces that extend over the edge towards the front, then wrap the piece around the perimeter with copper foil tape. Turn the piece over and use a craft knife to trim off the tabs that extend past the piece of copper foil tape you just applied. Burnish.

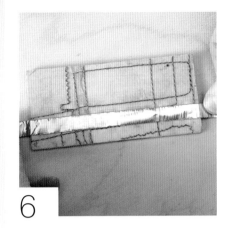

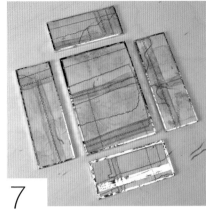

7 Wrap the rest of your pieces with copper foil tape, then burnish, flux and tin.

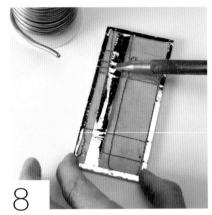

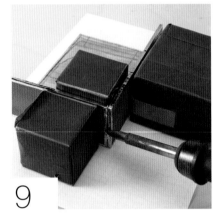

8 Don't forget to tin the strip along the bottom.

9 Using the weights or boxes and grid paper used in the *Pencil House* project instructions, tack solder the pieces and assemble the box.

10 Once the box is tack soldered together, fill in any gaps. When you are filling in crevices like this, you can hold the solder length with the iron as you move along.

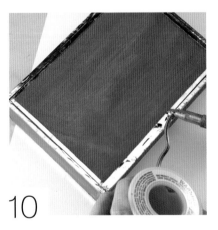

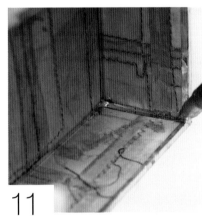

11 Don't forget to tin the inside seams of the copper foil tape. Keep in mind when tinning the very top edge that you don't want to create any bumps with the solder because when you attach your glass, it needs to be flush. After you are done filling in all of the nooks and crannies and the solder is cooled, burnish it and flatten any spots that need to be flattened. Because you are not working on glass, the copper tape tends to pull up.

12 To reinforce the copper letter, add a beaded layer of solder. To do this, apply a thin layer of flux and melt solder on top of the letter until you get a domed surface.

13 Remember, this little letter is extremely hot!

14 Clean the solder and patina.

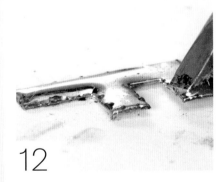

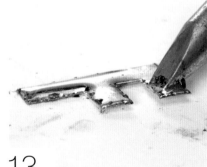

Visit **www.createmixedmedia.com/soldertechniquestudio** for extras.

14

15

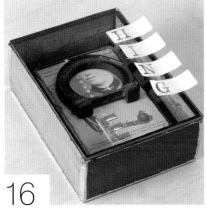

16

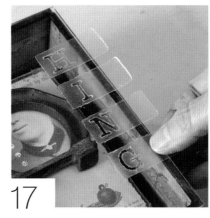

17

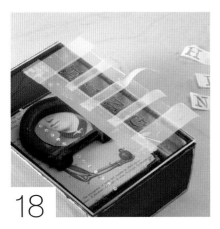

18

19

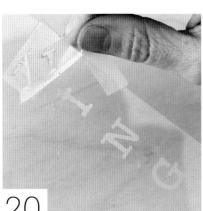

20

21

15 Assemble your ephemera and found objects into a collage. To add depth, I used foam core and glued it to the back of the assemblage.

16 Affix your assemblage inside the box using glue. Set it aside and allow it to dry. Measure the overall size of your box. Cut out a piece of glass to those dimensions. Plan out your composition by placing the contact paper stencil letters on top of the glass.

17 Remove the backing and affix the stencil to the glass. Burnish the masks down before you apply your etching solution.

18 Put clear tape between the letters.

19 Time to etch. Put on your gloves and apply etching solution following the manufacturer's instructions. Don't force the etching solution into the stencil; gently dab onto the glass. This should take about five minutes to etch the letters into the glass.

20 Once you have rinsed off the etching solution, peel off the letter stencil.

21 Solder the copper letter in a vertical position on the bottom portion of the box. Attaching the letter is like attaching a jump ring; you need to hold it until the solder cools.

22

23

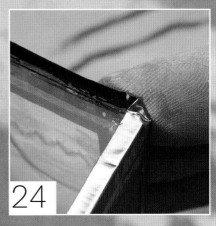

24

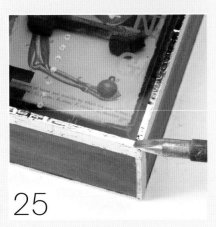

25

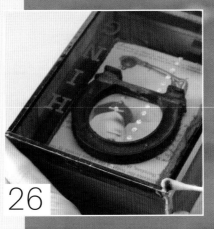

26

22 Remove flux residue from the letter and patina the letter.

23 Clean the glass and set on top of the box. Using copper foil tape tabs, affix the glass to the box.

24 Wrap the glass with black-backed copper tape.

25 Tin the box.

26 Clean the solder, then patina and give the glass a final shine. This might possibly be the hardest part of this whole project.

TIP

When adding flux to anything other than glass, be a little more neat with your flux when applying it.

➔ Don't cut your glass until you have your box assembled because until you have it together, it is hard to guess what the final measurements for the glass will be.

➔ Cut the balsa wood with a hacksaw or jeweler's saw.

➔ For the collage to stand out, I applied three pieces of foam core to the back to make it pop from the background.

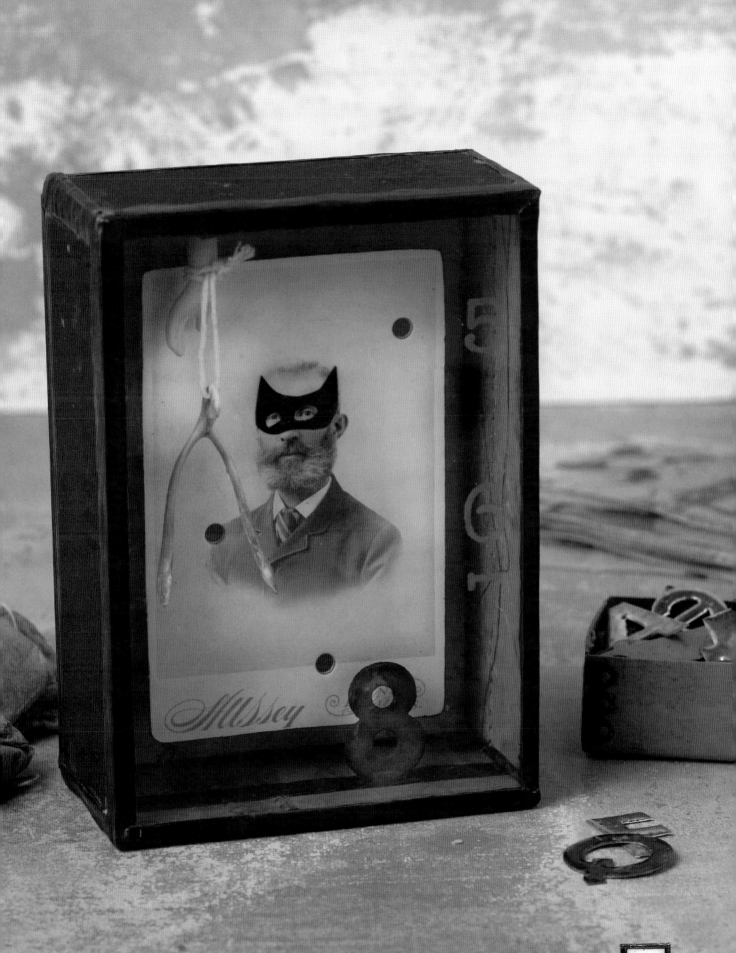

Materials

- Basic soldering tool kit
- Solder, 60/40
- Copper foil tape, cut to size
- ½" (12mm) copper foil tape for the back
- Glass, 11 pieces cut to size
- Collaged paper
- Mat board, cut to the same size as the glass used for the back
- Grid paper
- Weights
- Antique frame
- E6000 epoxy
- Jump rings

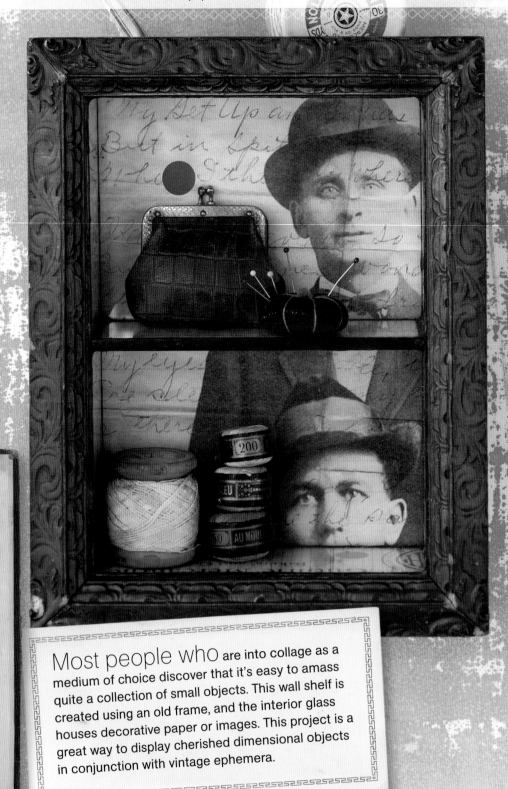

Wee Things

Most people who are into collage as a medium of choice discover that it's easy to amass quite a collection of small objects. This wall shelf is created using an old frame, and the interior glass houses decorative paper or images. This project is a great way to display cherished dimensional objects in conjunction with vintage ephemera.

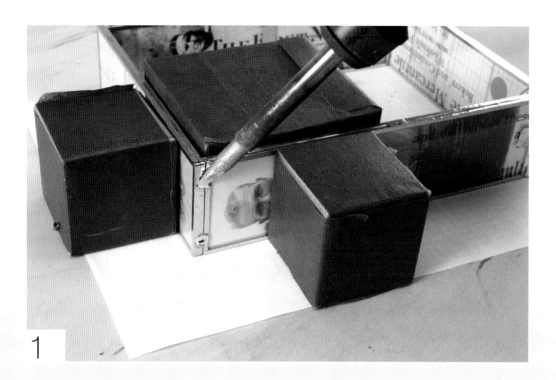

1

1 The most important step of this project is measuring the glass. You want the top and the sides of the box to sit inside the lip on the back of the frame.

You will need eight pieces of glass and eight corresponding images to assemble the side edges of the box; there are two pieces of glass per side.

You will need a ninth piece of glass and a ninth image and a same-size piece of mat board to serve as the back.

If you want to add a shelf in the interior portion of your box, you need to add a piece of copper foil tape to serve as a bracket (see step 2). Place this piece of copper foil tape on the inside midsection of the interior piece of glass.

Wrap the pieces of the glass with copper foil tape (see wrapping instructions found in the *Toggle-Clasp Pendant* project.

Assemble the sides of the box like seen in the *Pencil House* project.

Once you have tack soldered the sides of the box, measure the area and cut out a piece of glass that will fit the back outer perimeter of the box.

You will need a collage image and a piece of mat board cut to the same size. Wrap with copper tape. Add an additional piece of ½" (12mm) copper foil tape to the top edge of the back (see photo 4).

Place the back on top of the tack soldered structure and tack solder the back into position.

TIP

If the tinned copper tape lifts off the mat board, once the solder cools off, burnish again.

2 Make a shelf. Measure the distance between the inside of the box and the depth of the box, then cut two pieces of glass. Make two collages for the shelf and cut them down to size. Wrap with copper foil tape and tack solder the shelf to the two brackets on the inside of the box.

3 Fill in any gaps along the shelf, seams and all edges around the box.

4 Make jump rings and solder those to the ½" (12mm) piece of copper foil tape on the back along the top of the box.

5 Clean the solder, then patina.

6 Next we are going to affix the frame to the front of the box.

7 Turn the frame over and place the box inside the lip of the frame. Use E6000 glue and fill in the gap between the glass and the frame. Add glue along all four sides.

8 Use a rag to remove any excess glue along the edge. Set aside to dry.

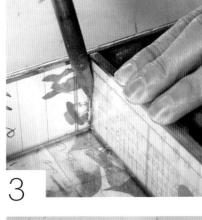

2

3

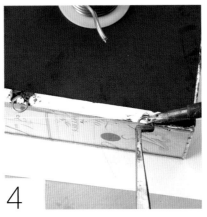

4

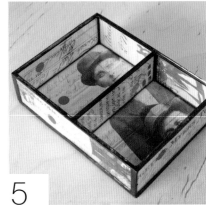

5

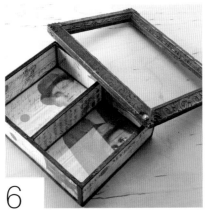

6

7

8

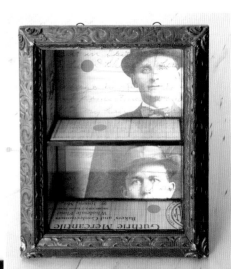

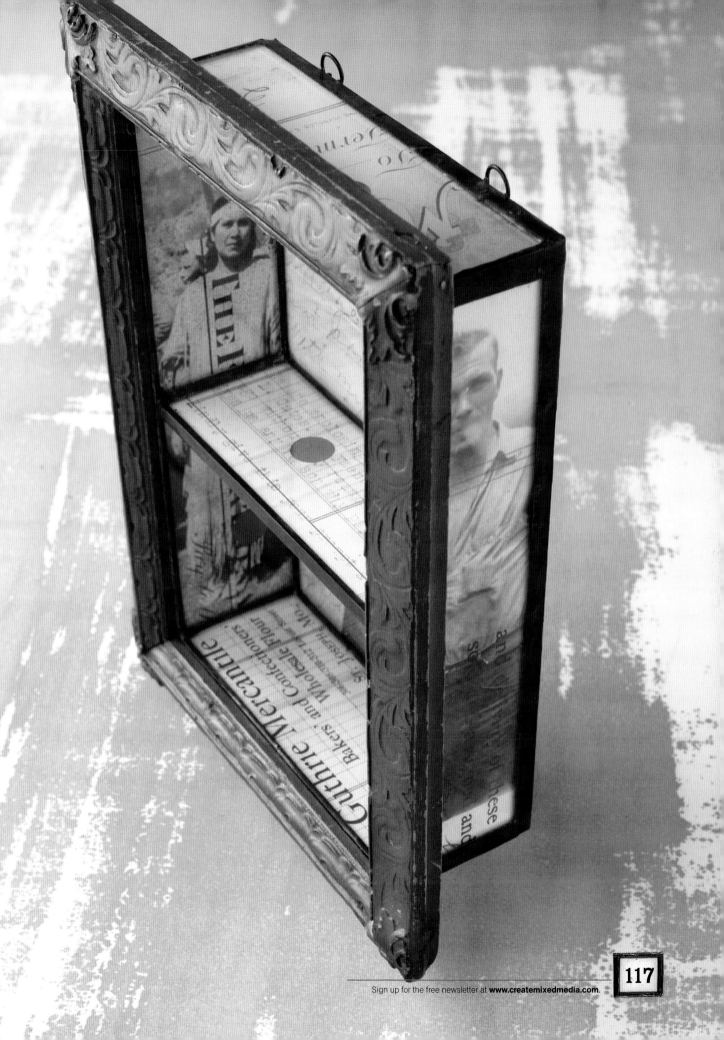

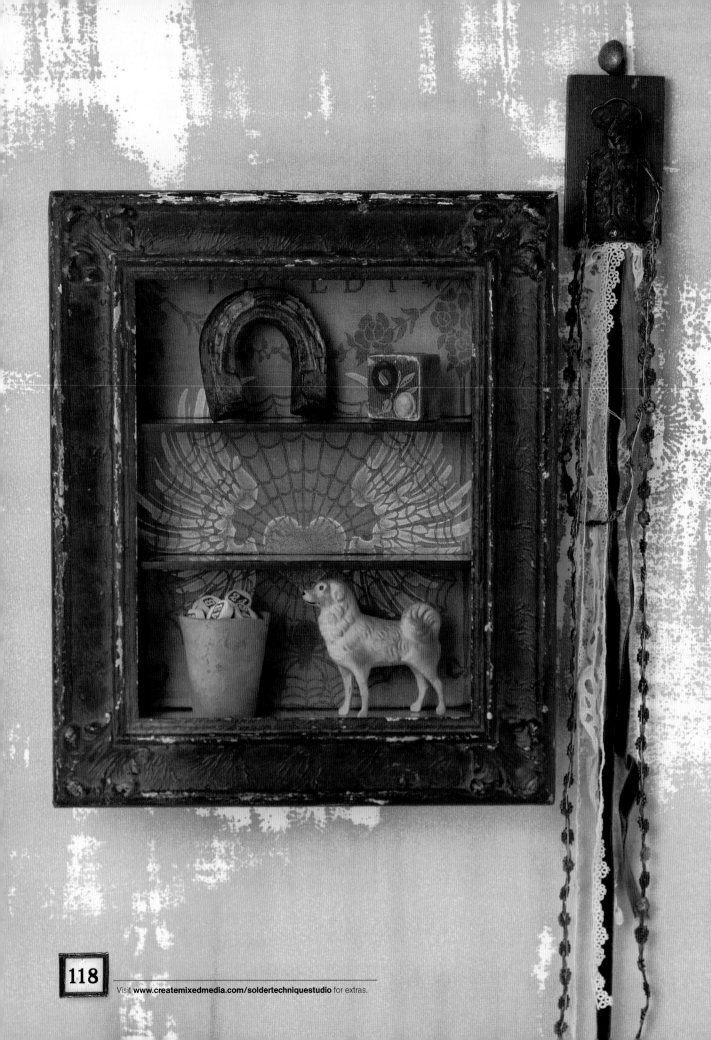

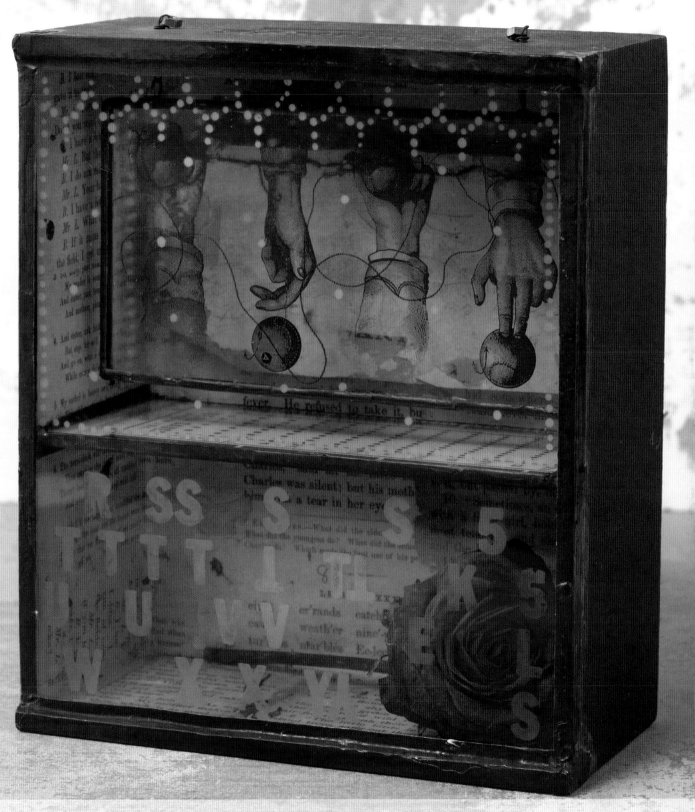

For this project, I dangled a soldered transparency between two pieces of glass in the top portion of the box for added dimension. I also tore the top off an old cigar box, removed the decals and painted the outside. If you are not up to building your own box, there are plenty of premade boxes to choose from.

Collage Starting Point

I want to share some of my favorite
goodies as a jumping-off point for creating
your very own collages for any of the
projects in the book.

"YOU AND YOUR WORM"

A MANUAL TO GUIDE
YOU ON THE CARE AND
TRAINING OF THE PET
WORM

A FIRST EDITION

BY S.K.W.

TRAINING
(CONT.)

FIRST SIGN OF DANGER
HE WILL CRAWL INTO
YOUR EAR AND SOUND
(OR IN THIS CASE
WIGGLE) THE ALARM!

A BELL ON HIS COLLAR
WOULD BE OF VALUE.

NOW THAT WE HAVE
COVERED SOME OF THE
THINGS YOU CAN TRAIN
YOUR WORM TO DO, GET
OUT THERE AND HAVE
A BALL, BUT REMEMBER
NOT TO DROP IT ON
HIM. REMEMBER TOO,
THAT YOUR WORM NEEDS
LOVE AND AFFECTION
AND HAS A TWO CHAMBER
ED HEART.

Templates

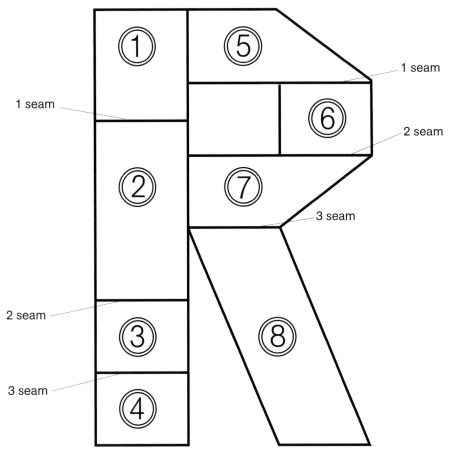

1 seam

1 seam

2 seam

2 seam

3 seam

3 seam

Spelling Bee Template

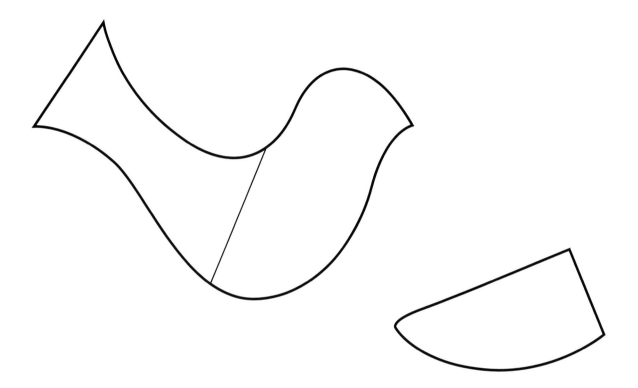

Bird Cutting Template

Resources

Bookbinding

Books by Hand
www.booksbyhand.com

Collage, Ephemera & Scrapbook Paper

Estate sales, yard sales, thrift stores, antique stores and online

7gypsies
www.sevengypsies.com

Cosmo Cricket
www.cosmocricket.com

Dover Publications
store.doverpublications.com

eBay
www.ebay.com

Jenni Bowlin Studio
www.jbsmercantile.com

Stampington & Company
www.stampington.com

Cuttlebug

Provo Craft
www.provocraft.com

Flux

Local stained glass stores and online
Denver Flux, liquid
Classic 100, gel flux
Sterling Flux, paste

Gel Medium

Golden Artist Colors
www.goldenpaints.com

Glass Cutters

Local stained glass stores and online
Toyo Glass Cutter
Easy-Cut Lens Cutter

Jewelry Supplies

Local craft, hobby, jewelry and beading supply stores and online

Rings & Things
Ball Chain and Chain
www.rings-things.com

The Bead Smith
Pliers
www.beadsmith.com

Patinas

Novacan
www.novacan.net

Jax
www.jaxchemicals.com

Polishing Compounds

Local stained glass stores and online

Wenol
www.wenol.com

Clarity Stained Glass Finishing Compound
www.clarityglass.com

Soldering Supplies

Local stained glass stores, hobby and craft stores and online

Canfield Technologies
Canfield Solder
www.canfieldmetals.com

Glastar
www.glastar.com

Inland Craft
www.inlandcraft.com

Johnson Manufacturing Co.
Sal Ammoniac Block
www.johnsonmfg.com

Venture Tape
Copper Foil Tape
www.venturetape.com

Weller
weller.de/new

Thin-Gauge Metals

The Whimsie Studio
www.whimsie.com

Tools

Harbor Freight Tools
Clamps, Flex Shaft
www.harborfreight.com

Miscellaneous

Anywhere Hole Punch
www.makingmemories.com

Armour Etch
www.armourproducts.com

Balsa Wood
www.midwestproducts.com

Chalk
www.panpastel.com

Con-Tact Paper
www.idsgj.com/kittrich/index.asp

Fiskars Scissors
www2.fiskars.com

HP Iron-on Transfers
www.hp.com

Sakura Gel Pens
www.sakuraofamerica.com

Sharpie
www.sharpie.com

Stamps
www.stampersanonymous.com
catslifepress.com
stampotique.com

StazOn Inks
www.tsukineko.com

Tea Bags
www.lipton.com

Tonic Shears
timholtz.com

Index

Sign up for the free newsletter at **www.createmixedmedia.com**.

Thank you to Carol Panaro-Smith for supplying Josie's photo. To see Carol's work, please go to alchemy-studio.net

Artist Documentary List

Around these parts I am known as a documentary junkie. I hope you find them as captivatingly interesting as I do. Below in no particular order is a list of some of my favorites:

In the Realms of the Unreal

Helvetica

Exit Through the Gift Shop

Beautiful Losers

Bomb It

Visual Acoustics: The Modernism of Julius Shulman

Jean-Michel Basquiat: The Radiant Child

Art & Copy

Art City Simplicity

Our City Dreams

Man on Wire

Picasso and Braque Go to the Movies

The Universe of Keith Haring

Absolute Wilson

Waiting for Hockney

Herb & Dorothy

Alice Neel

Between the Folds

Acknowledgements

I would like to thank Tonia Davenport, North Light's Mixed-Media Acquisitions Editor, for believing I could pull off another book. Christine Polomsky, for another fun-filled photo shoot and the Beatles photograph (it's in my workroom); Bethany Anderson and Ronson Slagle, who follow the golden rule of "Less is More"; Ric Deliantoni, the eBook video director, for making an otherwise fingernail-biting experience seamless; and finally, the F+W Media family for all their support and amazing opportunities.

Visit **www.createmixedmedia.com/soldertechniquestudio** for extras.

www.fwmedia.com

16 15 14 13 12 5 4 3 2 1

DISTRIBUTED IN CANADA BY FRASER DIRECT
100 Armstrong Avenue
Georgetown, ON, Canada L7G 5S4
Tel: (905) 877-4411

DISTRIBUTED IN THE U.K. AND EUROPE BY F&W MEDIA INTERNATIONAL
Brunel House, Newton Abbot, Devon, TQ12 4PU, England
Tel: (+44) 1626 323200, Fax: (+44) 1626 323319
E-mail: enquiries@fwmedia.com

DISTRIBUTED IN AUSTRALIA BY CAPRICORN LINK
P.O. Box 704, S. Windsor NSW, 2756 Australia
Tel: (02) 4577-3555

SRN: W1810
ISBN-13: 978-1-4403-1435-3
ISBN-10: 1-4403-1435-7

EDITOR BETHANY ANDERSON
DESIGNER... RONSON SLAGLE
PHOTO STYLIST JAN NICKUM
PRODUCTION COORDINATOR .. MARK GRIFFIN
PHOTOGRAPHERS CHRISTINE POLOMSKY,
RIC DELIANTONI AND
AL PARRISH

METRIC CONVERSION CHART

To convert	to	multiply by
Inches	Centimeters	2.54
Centimeters	Inches	0.4
Feet	Centimeters	30.5
Centimeters	Feet	0.03
Yards	Meters	0.9
Meters	Yards	1.1

Sign up for the free newsletter at **www.createmixedmedia.com**.

More inspiration!

Visit www.createmixedmedia.com/soldertechniquestudio for extras to download from *Solder Technique Studio*.

These and other fine North Light products are available at your favorite art and craft retailer, bookstore or online supplier. Visit our website at www.createmixedmedia.com for more information.

A GREAT COMMUNITY TO INSPIRE YOU EVERY DAY!

→ Connect with your favorite mixed-media artists

→ Get the latest in journaling, collage and mixed-media instruction, tips, techniques and information

→ Be the first to get special deals on the products you need to improve your mixed-media creations

Follow **CreateMixedMedia. com** for the latest news, free wallpapers, free demos and chances to win FREE BOOKS!

Follow us @cMixedMedia

For inspiration delivered to your inbox, sign up for our FREE e-mail newsletter.